Playing with
Image Transfers

Exploring Creative Imagery for use in Art, Mixed Media, and Design

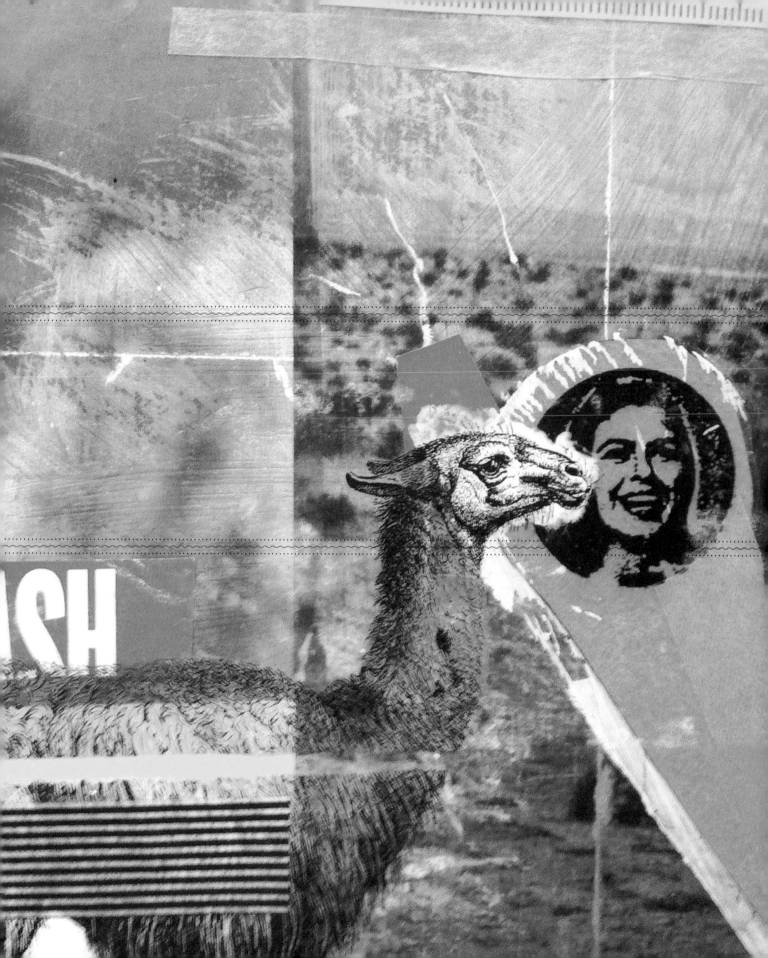

Playing with
Image Transfers

Exploring Creative Imagery for use in Art, Mixed Media, and Design

Courtney Cerruti

Quarry Books
100 Cummings Center, Suite 406L
Beverly, MA 01915

quarrybooks.com • craftside.typepad.com

First published in the United States of America in 2013 by
Quarry Books, a member of
Quayside Publishing Group
100 Cummings Center
Suite 406-L
Beverly, Massachusetts 01915-6101
Telephone: (978) 282-9590
Fax: (978) 283-2742
www.quarrybooks.com
Visit www.Craftside.Typepad.com for a behind-the-scenes peek
at our crafty world!

10 9 8 7 6 5 4 3 2 1

ISBN: 978-1-59253-856-0

Digital edition published in 2013
eISBN: 978-1-61058-916-1

Library of Congress Cataloging-in-Publication Data

Cerruti, Courtney.
 Playing with image transfers : exploring creative imagery for use in art,
mixed media, and design / Courtney Cerruti.
 pages cm
 ISBN 978-1-59253-856-0 (pbk.)
 1. Transfer-printing. I. Title.
 TT852.7.C47 2013
 746.6'2--dc23
 2013024612

Design: Studioink - www.studioink.co.uk
Cover Image: Courtney Cerruti (top left, top right, bottom right)
and Alisa Nordholt-Dean (bottom left)

Printed in China

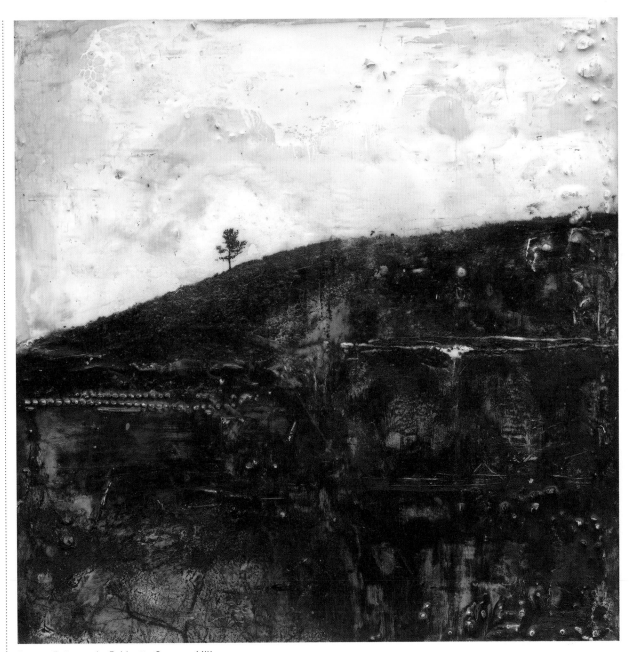

Spaces Between by Bridgette Guerzon Mills
encaustic mixed media

Dedication

For the women who started as interns and became friends; for your hard work, vision, and creativity; for making impossible days successful ones. For Shân, Veronica, Shannon, and Kelsea. I am so grateful. Thank you.

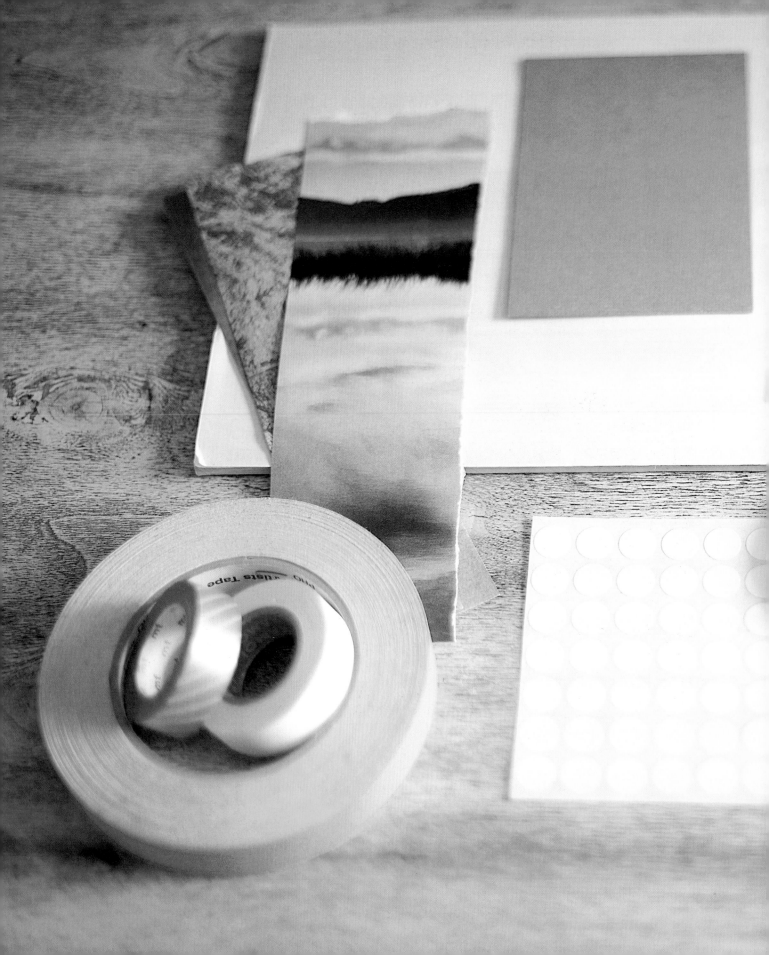

Contents

Introduction

Image transfers live in this undefined space in art making … they are neither photograph nor painting; they are neither print nor collage. Like an elusive nighttime creature, they are hard to explain to anyone who hasn't seen one. Their ephemeral beauty goes beyond the image alone, as they hover between mediums, inhabiting a space somewhere outside of traditional form.

I was in high school, sitting on my bedroom floor looking at an image of LK Ludwig's in the book *Making Journals by Hand* by Jason Thompson. The image was a self-portrait transferred onto a mailing tag. It wasn't a photograph or a painting, it was something else entirely … the piece was ghostly and romantic and one of the most painterly and beautiful images I had ever seen. I read her how-to and called every store I could think of to find this substance called xylene. After discovering I couldn't get it in California, I asked my dad to bring a bottle back from his next fishing trip to Nevada. He did, and I've been playing with image transfers ever since. I've experimented, tried, and tested every method and process out there. After many failures and many discoveries, I've settled into a set of methods that work both beautifully and consistently.

I believe in processes that are accessible and successful, processes that can be done without expensive equipment and on your kitchen table in the time you DO have to make something, which can be as little as five minutes. Like any art process, so much of this is about experimentation. Give yourself the time and place to play with these methods. Delve into the projects, discover what you love and how it applies to the work you want to make, and then create your own best methods. Fly off in your own direction with a set of skills that will allow you to create the images and work you only tiptoed around before. One of the reasons I love working with image transfers is that they are versatile. They have the capability to be as layered and as complex as you need them to be or simple and immediate. I love that I can create a transfer in a few minutes and make art in a way that

fits into even the busiest moments of my life. They delight the imagination of artists new to their practice as well as seasoned artists who are looking to add dimension and depth to their current work. Image transfers continue to engage and surprise me fifteen years after that first moment when I was seduced and fell so deeply in love.

Opposite: Sunshine Followed by Sarah Ahearn Bellmare

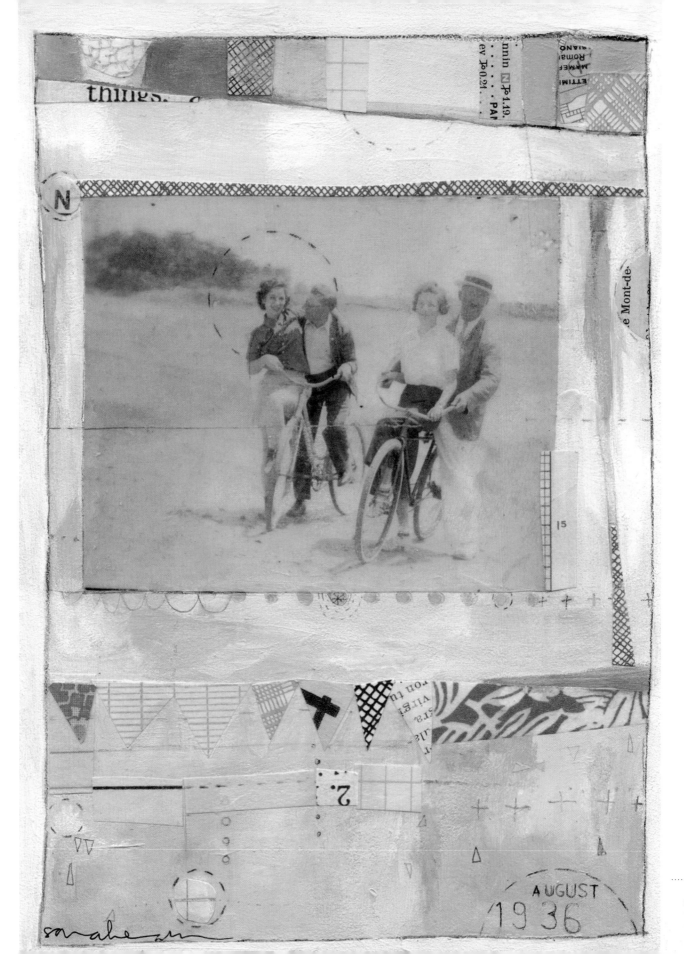

GETTING STARTED:
Materials and Transfer Techniques

Creating successful image transfers is easy once you understand the process and have the technique down. It's always helpful to use the right materials for any project, and knowing what works best will get you on the road to making beautiful and successful transfers without frustration. Here are some basics for knowing how and why certain materials work and which will yield the best results.

Types of Images

In general, high-contrast images work best for all image transfers, both color and black and white. For this reason, clip art, copies of line drawings and sketches, and type and text make clean transfers. You'll discover you can bend this rule with packing tape transfers because they are the most forgiving transfer of all, but when making transfers with personal photos, aim for images with bold blocks of color and high contrast, whether they are in color or black and white.

PHOTOCOPIES AND LASER PRINTS

Many of the projects in this book use photocopies, not inkjet prints, and it is helpful to understand why. Laser prints and photocopies are made with toner instead of ink and use a heat process to set the toner in place. Toner sits on the surface of the paper, allowing it to be released when making a transfer. Ink from an inkjet printer absorbs into the fibers of the paper and cannot be released and therefore cannot make a transfer. If you're not sure whether you have a laser or an ink-jet printer, check to see whether the paper is warm when it comes out of the printer. If it is warm, you have a laser printer; if it is not, you have an ink-jet printer. Both color and black-and-white photocopy machines use toner.

BLACK-AND-WHITE IMAGES

Many image transfers work best when using black-and-white photocopies. There are two reasons for this. First, the photocopy process usually enhances the contrast of the photo, making it bolder and more defined, which generally translates into a better transfer. Second, the toner on a black-and-white photocopy (as opposed to a color copy) is more saturated and can be easier to transfer. If you start with a picture of you and your best friend standing in front of a lake, in front of a mountain, under a blue sky, and you make a black-and-white photocopy, you will end up with an image that looks like a blob of gray. This in turn will create a transfer that looks like a blob of

gray. Any transfer is as good as the photocopy or original image you start with, so keep this in mind as you prepare images to transfer. When making black-and-white copies, use a regular weight copy paper such as 20 pound for best results, which is standard at most copy shops. Avoid using heavy or glossy-coated paper stock.

COLOR IMAGES

In certain processes, color images can be trickier to work with. For whatever reason, color laser printers and photocopy machines can have more variables than their black-and-white counterparts, which means you may make a batch of color copies that don't seem to work well. This may be because of the amount of toner, or the saturation of the image, or just because. Don't despair: almost any failed color copy will work with packing tape transfers. Do an experiment and try different printers and machines at your local copy shop until you find one that yields successful copies for whichever transfer method you're working with. When making color copies, use a lightweight copy paper such as 24 pound for best results. Avoid using heavy or glossy-coated paper stock.

MAGAZINE PAGES

Found images and text can be a great source of inspiration in your work, and magazines are an immediate and inexpensive way to gather found imagery. Glossy pages work best for transfers, and you'll find that matte printed pages will yield faint and ghostly

transfers. Using magazines is a great way to repurpose something that would otherwise be destined for the recycling bin. They also provide great, ready-made words and phrases, which are fun to experiment with, especially if you don't like adding your own handwriting to your work. I especially enjoy using old *National Geographic* magazines. They are easy to find at library book sales and thrift stores and have great, saturated images.

FOUND IMAGES

If you're not quite ready to use your own imagery or want to experiment with a certain theme or image, consider using clip art. A great resource for found images and text is Dover Publications. They've published innumerable volumes of graphics taken from historic, scientific, and cultural sources, all curated into tidy, themed collections. Most of the images are made from engravings, which means the images can have a ton of detail but are still just black and white. What appears as subtle gray color and shading is actually made from tiny black lines. This distinction makes them particularly suitable for transfer processes. Because Dover has been publishing these types of books for decades, these volumes are easily found in bookstores. My other favorite source of clip art is *Crap Hound* magazine. Yep, *Crap Hound*. They are categorized into themes such as Hands, Hearts and Eyes, Clowns, Devils, or Bait. These off-the-cuff compendiums are worth their weight in gold. Check the resource guide for where to find them.

Transfer Materials and Mediums

There are many different ways to make transfers. These materials are my tried-and-true go-tos for the projects in this book. They consistently create beautiful results. Feel free to experiment and explore with mediums you may already have. If you are struggling with creating transfers, check your materials and make sure you have the basics covered before you branch out to other mediums.

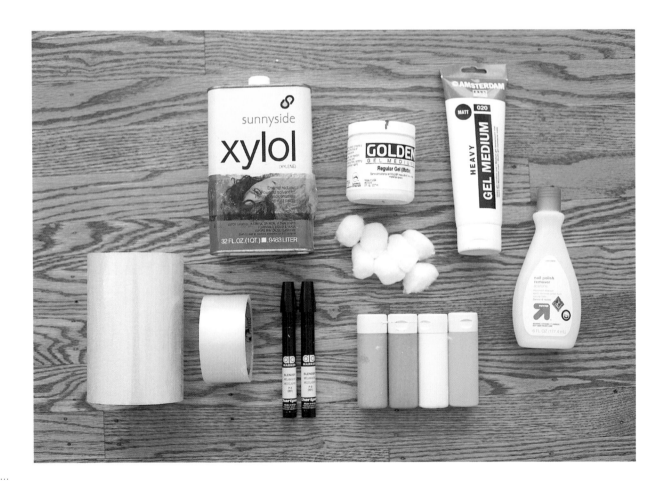

PACKING TAPE

You can find packing tape at the hardware store, the grocery store, or even at the dollar store. The quality of tape, whether it costs $1 a roll or $5 a roll, makes very little difference when creating a transfer. Some brands will be thicker (not wider), some stickier, and all will have a glossy finish. Start with whatever you have at home and then experiment with various brands. I recently found packing tape that comes wider than the standard 2-inch (5 cm) variety, and I was thrilled. It is harder to work with, but can be oh so fun!

MEDIUMS

I love gel medium. No, really, it's amazing. I use it for all kinds of mixed-media work as both a glue and a sealant. It's a miracle medium. It can be tinted, mixed with acrylic paints, and cleaned up with water. It's not expensive to use, but it's expensive to waste, which is why you should always keep it capped when you're working so it doesn't dry out. Scoop a dollop onto a piece of waxed paper when working and just fold in half to keep it wet. Gloss gel medium works too, but it tends to be thinner, which means you'll need to use more layers when making a gel skin transfer.

SOLVENTS

For most solvent transfers, I recommend using a blender pen, which you can find with the fancy fashion and design markers at most art supply stores. It's a clear "ink" pen that blends two colors together. There are several brands out there, but Chartpak works the best. The Chartpak pen is AAP nontoxic, which means it has the seal of approval from American Academy of Pediatrics for safe use, but it is smelly, so use in a well-ventilated area. The main chemical in a blender pen is xylene or xylol, which you can buy from art supply stores in a tin, like turpenoid or paint thinner. It is not nontoxic, and I rarely use it straight. If you decide your project requires using xylene from a bottle, be sure to work outside with a mask and gloves and read the manufacture's warning. Acetone is another solvent that works well for many types of transfers. You can find this at the hardware store near the paint stripper or you can buy a small quantity from the drug store as nail polish remover, but make sure it has a high percentage of acetone, 90 to 100 percent. Using a blender pen is great because it has a controlled release of solvent through the marker tip, but for larger projects or for working with color photocopies, using solvent from a bottle works better and can be applied with cotton balls.

ACRYLIC PAINT

Normally I would advocate using high-quality paints with a concentration of pigment, but for acrylic transfers, I use cheap craft paint. Craft paint comes in a variety of colors and usually has a significant amount of white base, which actually works great for transfers because it enhances the saturation of the image. You can play around with color without a lot of investment, experimenting with various bodies and brands. When selecting a paint, look for acrylic, something that is smooth to brush on, and medium to light in color (depending on your image and desired effect).

Transfer Surfaces

The surface on which you transfer is as important as the image you transfer. In general, smooth, porous surfaces will receive a transfer best. This could be paper, card, a smooth fabric, or even wood. It is important that the surface be clean (free of oil and grime) and uncoated. Glossy or shiny papers can cause smeared transfers, as would a varnish-coated wood panel. Fabrics with sizing or treated surfaces can also cause transfers not to take. Balsa, bass, and other craft woods work great, as do some shiny satinlike fabrics, muslin, and canvas.

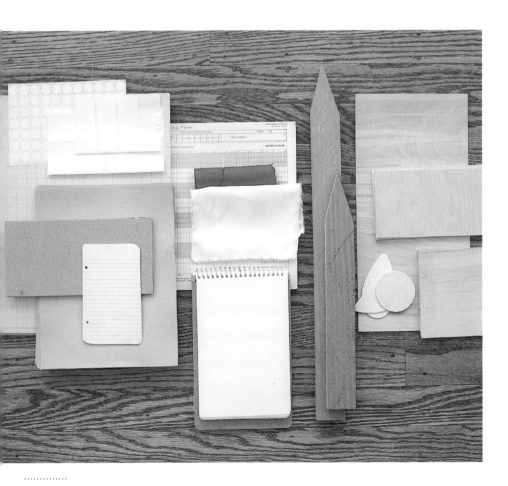

The great thing about image transfers is that you are transferring ink only. Unlike collage, where you cut something out with its background, image transfers allow you to layer images and media without adding bulk. For that reason, I love to transfer on found papers such as ledgers or books that already have a layer of pattern or text. Experiment with transfer surfaces and discover what you like best.

Art Supplies

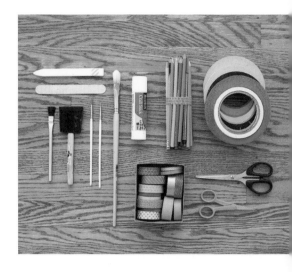

I love art supplies of all shapes, sizes, and functions, and I can be easily seduced by a pretty package or an enticing graphic. But some tools and ephemera I come back to again and again to use in my work. Here are some of my favorite materials.

BRUSHES

You can use hardware store brushes, glue brushes, or finer bodied paintbrushes. Keep in mind that cheaper brushes can have a coarser texture that will show up in some of your transfers. This can give a great distressed look. If you're transferring an image with fine detail, consider using a smoother brush. Both acrylic and gel medium are water based and easy to clean, but both dry quickly, which can ruin an expensive brush if neglected.

ADHESIVES

For quick paper-to-paper adhesion, Scotch brand Craft (glue) Stick is my go-to; I also like Scotch brand double-sided tape. For heavier paper-to-paper adhesion, I use PVA (polyvinyl acetate), which is a standard bookbinding glue similar to Elmer's white glue but thicker, with less moisture, and faster drying. I also love gel medium as an adhesive and sealant; it is especially handy when sticking down little bits of ephemera or delicate papers. Tacky glue is great for adding bulky or heavy items to mixed-media work.

SCISSORS

A sharp pair of scissors is great to have on hand.

BURNISHING TOOLS

A bone folder is an all-purpose burnishing tool that folds, scores, and creases as well. A good substitute in a pinch is a large wooden craft stick (or Popsicle stick) or the back of a butter knife. I often use an old library card or credit card to burnish, allowing me to apply dispersed, even pressure. You can also use a library card to squeegee medium or glue onto a surface evenly.

TAPE

I'm addicted to tape, and I'm a professed converter. I love artist's tape (which is repositionable on paper) in black and natural. It comes in a range of sizes, and they are all amazing! I love neon artist's tape as well. A pop of neon is a beautiful thing! I'm also in love with washi tape. Washi tape is a Japanese tape made from washi paper; it's low tack and slightly transparent. It comes in a variety of colors and patterns and is great to use in collages, sketchbooks, correspondence, and mixed-media work. I also love Sellotape or permanent double-sided tape for layering paper (Scotch brand is best).

Collage Materials

I tend to go for found and vintage when it comes to paper. Some of my favorites to layer in sketchbooks and on postcards are old maps, sewing pattern paper, cut-up book pages or dictionary pages, old photos, torn bits of magazines for bright colors or fun text, and anything with an interesting pattern or print. The inside of the envelopes that bills come in are great, too; the security pattern makes interesting collage material. Vintage papers are easily found at flea markets, thrift shops, library book sales, and online. They are inexpensive and thrilling to hunt down.

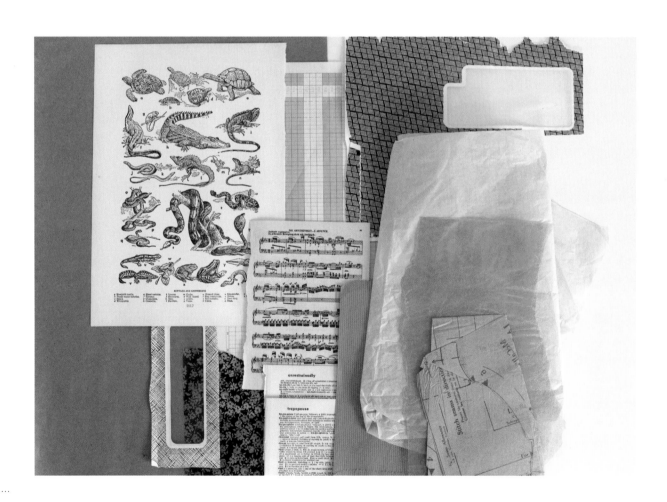

Odds and Ends

There are several items that I always have lying around my studio, and I come back to them again and again no mater what project I'm working on.

BABY WIPES

Unscented baby wipes are an artist's best friend. They keep a brush from drying out in between working time and are great for cleaning fingers sticky with glue or paint, wiping up a quick spill, or using as an artistic implement to smear, smudge, and moisten! You'll be buying these in bulk before you know it.

DISH PAN, SPONGE, AND DISH TOWEL

I have a dedicated plastic dishwashing tub that I take from class to class for making image transfers. It's about 18 inches (45.7 cm) long by 12 inches (30.5 cm) wide and 6 inches (15.2 cm) deep. You can use just about anything (and the sink is fine, too), but be mindful that you'll be using it over and over and you want something that feels comfortable. Containers that are too shallow or too short can be uncomfortable if making a lot of transfers at once. Having a sponge and dish towel handy makes life easy when working with water.

WAXED PAPER

Waxed paper is an all purpose material that I can't live without. I love the natural (unbleached) kind, which has a lovely brown color. It's great for using as a palette and even as an element in collage, as well as for protecting your workspace and layering between work when drying, transporting, or storing.

COOKING OIL

I often use cooking oil to add a satin shine to certain types of transfers or to make remnant paper fibers disappear on transfers.

HEAT GUN OR HAIR DRYER

This can come in handy if you want to speed the drying process when using acrylic paint or gel transfers. Be careful not to burn your work, your surface, or your hands.

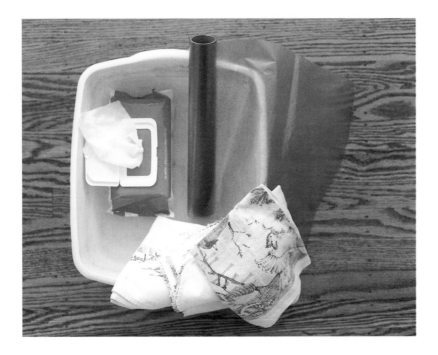

019

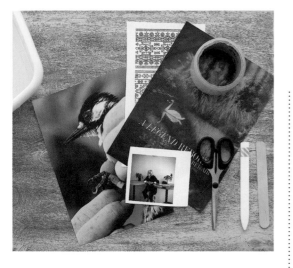

Packing Tape Transfer

- Use with black-and-white or color photocopies or laser prints.
- Use with magazine pages.
- Process does not reverse the image.

Packing tape is sticky and static-y, so it can take a few tries to master working with it. In the beginning, start with small, manageable strips and work your way up from there.

1 Cut a strip of packing tape the size of your image. Carefully lay the tape, sticky side down, across the image, starting at one end and slowly working your way across. Press down the tape with your fingers and then burnish with a bone folder from the center out to remove any bubbles or creases. (See A.) Burnish thoroughly so that the ink from the image sticks to the tape. Anywhere there is a bubble or crease will be clear or blank. If you do get a bubble or crease you cannot burnish out, don't worry—this can add an interesting distressed effect to your transfer. (See B.)

2 Tear or cut around the tape and place into the basin of warm water with the tape glossy side down and the paper facing you. (See C.)

3 With your thumbs, rub (do not scratch) away the paper backing until all the paper pulp is removed. Once the tape is wet, you may not be able to see any remaining paper, but you will be able to feel its fibrous and fuzzy texture. A finished transfer will be smooth. The great thing about packing tape transfers is their immediacy and forgiving nature. You can leave packing tape transfers in water and they won't dissolve or deteriorate. This is especially helpful when working with thicker paper. You can also rub quite aggressively without harming them. (See D.)

4 Once the pulp is gone, remove the tape from the water. Squeegee the length of the tape with your fingers and allow it to dry on a nonporous surface such as metal, plastic, or glass or sticky side up on a piece of waxed paper. (See E.)

5 As the transfer dries, the tape will become sticky again. The tape brand and type of magazine page can affect the level of stickiness, so experiment until you find what you like to work with. Use a glue stick if the transfer isn't sticky enough. If any paper fibers reappear after the transfer has dried, remoisten the tape with water and continue to rub away the fibers. Save your dried transfers on waxed paper for future use. (See F.)

6 When the transfer is finished, scoop out the paper pulp from your basin and discard. Instead of pouring the remaining water down the drain, flush it down the toilet. If you're feeling particularly crafty, you can use the paper pulp and water to make your own paper!

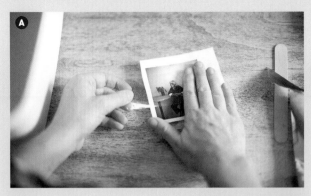

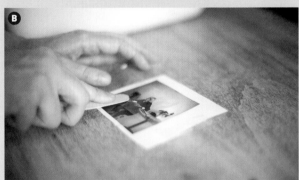

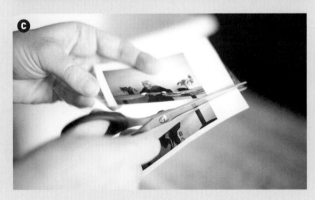

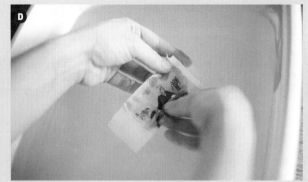

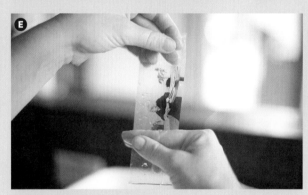

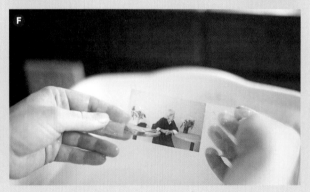

✂ MATERIALS

- ✔ scissors
- ✔ packing tape
- ✔ photocopy or magazine page
- ✔ bone folder or other burnishing tool
- ✔ basin or bowl of warm water
- ✔ waxed paper

TIP

If you want to make an odd shape or cut around an image, do so after you've made the transfer and removed the paper backing, not before. Although packing tape is pretty resilient, once you cut into it, you can easily tear your transfer when rubbing away paper fibers.

METHOD

Blender Pen Transfer

B lender pen transfers are a quick and easy way to transfer a black-and-white image. One you get familiar with the technique, you'll be addicted to the immediacy of this transfer.

- ❋ Use with black-and-white photocopies.
- ❋ Process reverses the image.

1 Select a high-contrast image to transfer. Trim your photocopied image down, leaving a 1/2-inch (1.3 cm) border. This gives you an area to hold the photocopy in place while transferring. Place the photocopy face down on your chosen surface. This can be paper, a book page, smooth uncoated wood, or smooth fabric.

2 "Color" the back of the photocopy with the blender pen. (See A.) While the paper is saturated, burnish the image with a bone folder. Try not to press too hard because you can risk smearing or blurring the transfer. Likewise, don't remove or shift the photocopy prematurely. (See B.)

3 Without shifting the photocopy, lift a corner and peek to see how the image is transferring. (See C.) If your image hasn't transferred all the way, "color" the image a second time and/or burnish again until the desired effect is reached.

4 Remove the photocopy to reveal the transfer. (See D.)

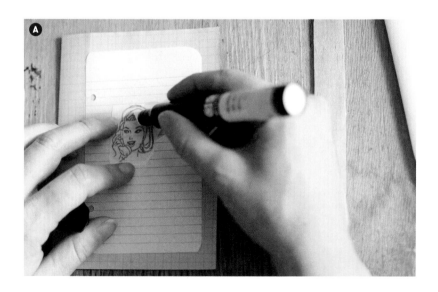

PLAYING WITH IMAGE TRANSFERS

022

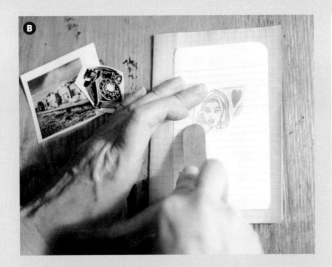

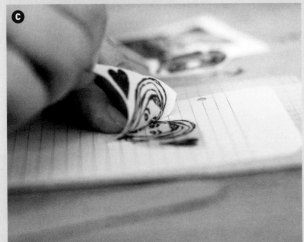

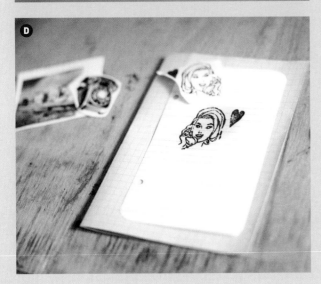

- black-and-white photocopy
- scissors
- paper, fabric, or other transfer surface
- Chartpak blender pen
- bone folder or other burnishing tool

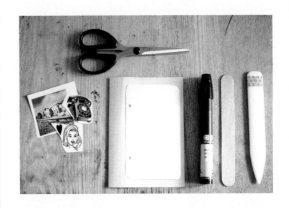

TIP

If the image is blurry, you may have oversaturated your photocopy with solvent or moved the image while transferring. If you aren't achieving the desired level of detail, check the surface on which you transferred. Smooth, uncoated surfaces work best for transfers. For example, smooth papers work better than watercolor papers, but both will receive transfers with varying results. The more texture on your chosen surface, the more distressed your transfer will appear. Occasionally, you may have a photocopy that won't work with the solvent. Don't despair. Try using any leftover copies with the packing tape, which is the most forgiving of all transfers. Note: Once a photocopy has been used for a solvent transfer, it cannot be used again. Too much of the ink has been removed to create a second successful transfer.

Acetone Transfer

Acetone transfers allow you to make a solvent-based transfer with a color image. You can also work with a larger image using this method. This type of transfer results in a more distressed, vintage feel, similar to a Polaroid transfer effect.

* Use with black-and-white or color photocopies.
* Process reverses the image.

1 Select a high-contrast image to transfer. Trim your photocopied image, leaving a 1/2-inch (1.3 cm) border. This gives you an area to hold the photocopy in place while transferring.

2 Place the photocopy face down on your chosen surface. This can be paper, a book page, smooth uncoated wood, or smooth fabric. (See A.) Dab the photocopy with a cotton ball saturated with acetone, about the same amount you'd use when removing nail polish. The paper will become transparent. While the paper is saturated, burnish the image with a bone folder. Don't be afraid to burnish aggressively. Unlike the blender pen, this transfer needs a little more muscle. Don't remove or shift the photocopy prematurely or you will blur the image.

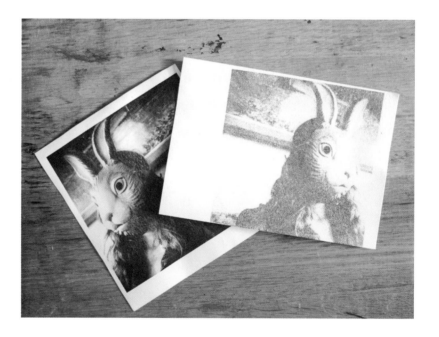

3 Lift a corner and peek to see how the image is transferring. You will most likely repeat this process several times while transferring because certain areas will start to dry. Continue dabbing the surface and burnishing until the image is transferred.

4 Remove the photocopy to reveal the transfer. (See B.)

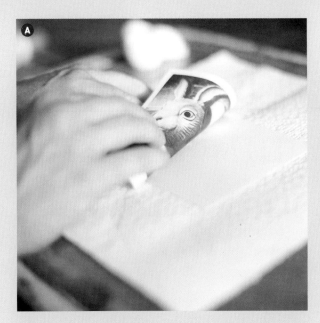

A

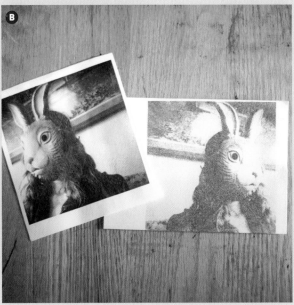

B

✂ MATERIALS

- ✔ black-and-white or color photocopy
- ✔ scissors
- ✔ paper, fabric, or other transfer surface
- ✔ cotton balls
- ✔ acetone
- ✔ bone folder or other burnishing tool

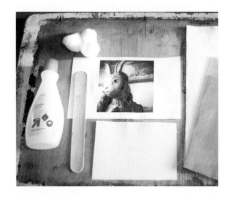

TIP

Acetone transfers are great because they can work with color photocopies. Overall, they give a much more distressed look, which can be really beautiful, but keep in mind that they result in a paler, more textured final image.

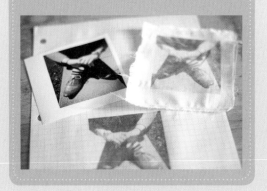

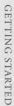

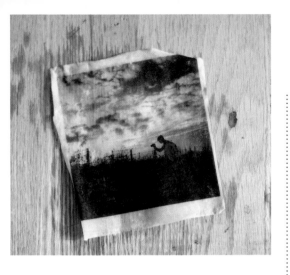

- ❋ Use with black-and-white or color photocopies.
- ❋ You can use either side of this transfer for different effects.

METHOD

Gel Skin Medium Transfer

T his is the most dimensional transfer of all. Gel skins can be used in a variety of art applications and mixed media.

1 With the photocopy face up, brush an even layer of gel medium onto the surface of the image. This layer should not be too thin or too thick. Be sure to brush the gel to 1/2 inch (1.3 cm) beyond the edge of the image. (See A.) Let this coat dry.

2 Repeat adding layers of gel, allowing each layer to dry between coats. Apply a minimum of five coats of gel. Do not be tempted to cheat because a thin gel skin will tear if you are not careful. If you are using a gloss medium, brush on a minimum of eight coats. (See B.)

3 Once the gel has dried completely, place it in a basin of warm (not hot) water. Gently rub, do not scratch, off the paper backing until the image is revealed. (See C.) Unlike packing tape transfers, gel skin transfers are fragile. Do not allow your gel transfer to soak in water because the transfer will eventually dissolve.

4 Allow the gel skin to dry flat on a piece of waxed paper. If paper fibers reappear when dry, simply re-wet and continue to rub away. Once dry, you can also rub in a couple drops of cooking oil, or brush on a dab of gel medium to any remnant fibers and they'll disappear.

5 Trim the gel skin to the desired size or leave the deckled edge. Use the transfer as is, or layer into a collage or acrylic painting.

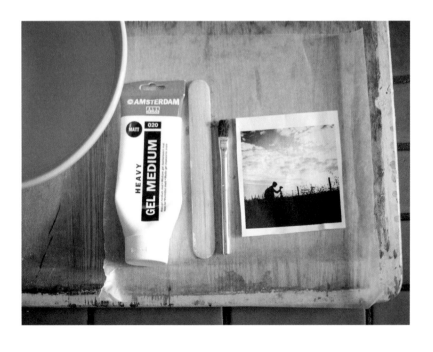

✂ MATERIALS

- ✔ black-and-white or color photocopy
- ✔ brush
- ✔ gel medium
- ✔ basin of warm water
- ✔ waxed paper
- ✔ cooking oil (optional)
- ✔ scissors

💬 CONSIDERATIONS

This transfer is so dimensional that it can be a piece of art on its own. You can paint directly onto the gel skin with acrylic paint or tint the gel with a liquid acrylic paint to create a colored skin. A gel medium transfer has great dimension and can be stitched as well.

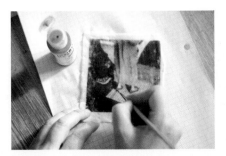

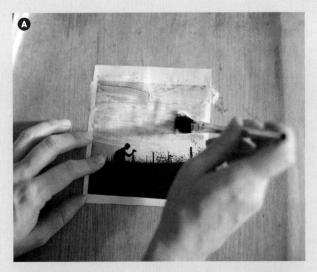

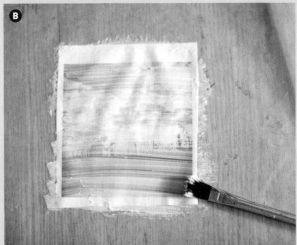

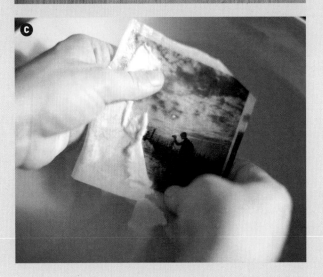

027

redshoes
2012

Acrylic Paint Transfer

- Use with black-and-white or color photocopies.
- Process reverses the image.

Working with black and white and color images allows you to get clean striking images or textured vintage looking images depending on how you manipulate the transfer. This method also works with gel medium, which acts like a clear paint in this application.

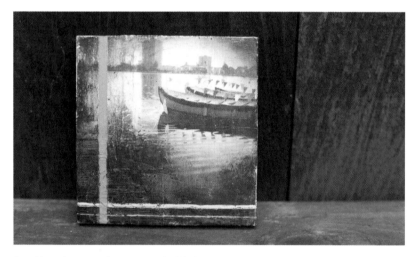

Acrylic paint transfer on wood with beeswax and paint overlay

1 Trim the photocopy image to leave little or no border.

2 Brush an even coat of craft paint onto your chosen surface; I've used bookboard here. (See A and B.)

3 While the paint is wet, place the photocopy face down into the paint. (See C.)

4 Burnish softly with your fingers. Be careful not to press so hard that you push the paint out from under the photocopy. Continue burnishing with a library or credit card.

5 Allow the burnished image to dry completely. I let this dry overnight so I'm not tempted to move on before the transfer is ready.

6 Once the transfer is dry, use a damp sponge to gently wet the transfer. Begin rubbing away the paper backing. Work in soft circular motions, wiping away paper pills as you go. Add small amounts of water as needed until the image is revealed. You may risk removing the paint if you rub too hard. (See D.)

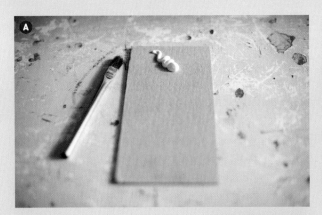

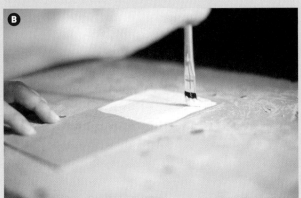

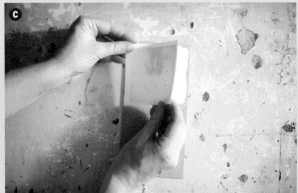

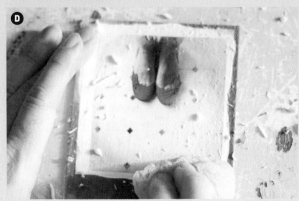

GETTING STARTED

✂ MATERIALS

- ✔ scissors
- ✔ black-and-white or color photocopy
- ✔ paintbrush
- ✔ craft-quality acrylic paint in a light or pastel color
- ✔ surface to transfer onto, such as wood, board, metal, or cardstock
- ✔ library or credit card
- ✔ sponge and water

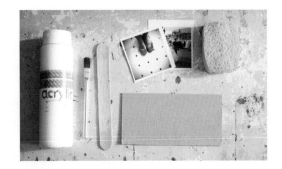

TIP

This transfer can go awry if you didn't apply a thick enough coat of paint, the paint wasn't wet when the photocopy was placed, or the transfer wasn't completely dry. Be patient and work through all the steps to get the best results.

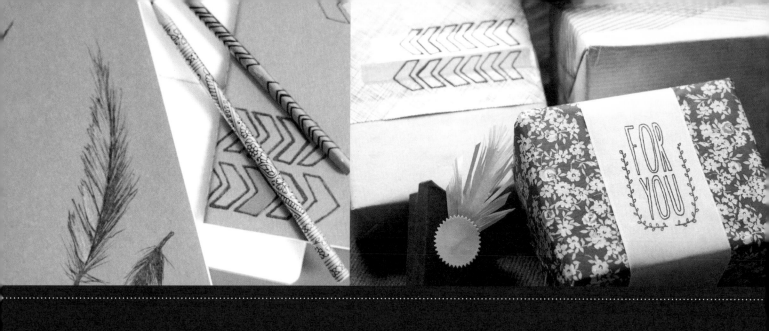

CHAPTER

2

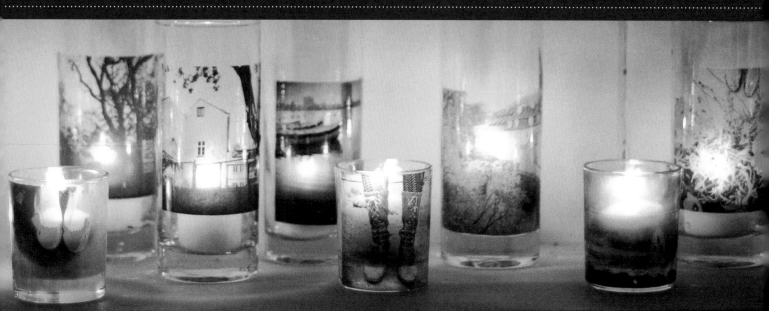

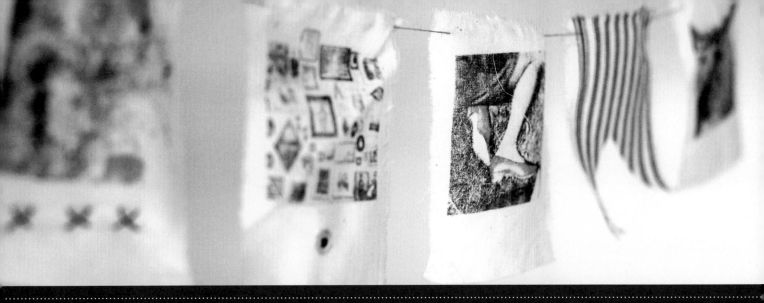

PURPOSEFUL PLAY:
Imagery and Ideas for Projects

"Almost all creativity involves purposeful play." – Abraham Maslow

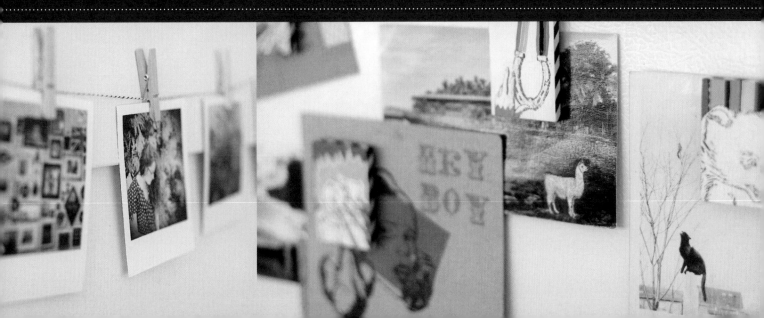

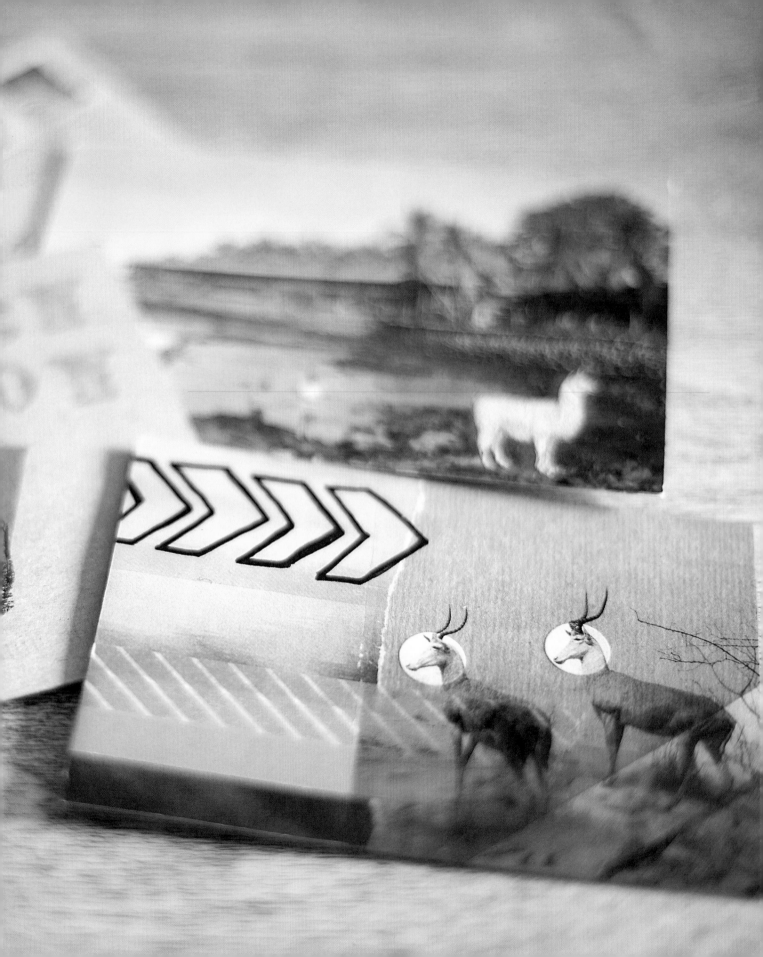

Project: Packing Tape Postcard

I love sending postcards. I like to transform vintage ones or make them from scratch. Layer bold graphics with found imagery using packing tape to create a dynamic piece of correspondence you can pop in the mail.

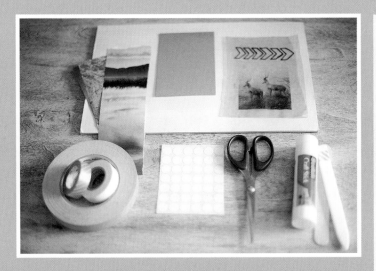

✂ MATERIALS

- ✔ Method: Packing Tape Transfer (see page 20)
- ✔ scissors
- ✔ magazine page or other paper ephemera
- ✔ blank postcard (cardstock cut down to 4 1/2" x 6" [11.4 x 15.2 cm])
- ✔ glue stick
- ✔ decorative tape
- ✔ small office circle labels (color-coding dots)
- ✔ bone folder or burnishing tool

🗨 CONSIDERATIONS

Packing tape postcards look great with transfers made with hand-drawn images or text. Combine family images with sketches and drawings to commemorate special trips, experiences, or occasions.

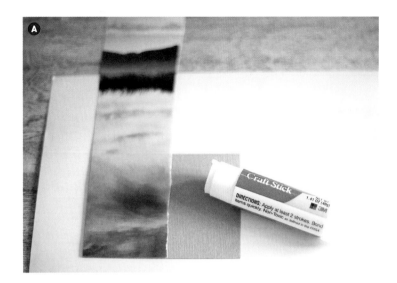

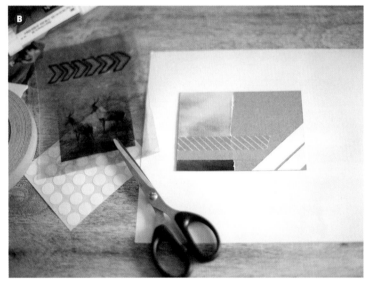

1 Create a striking composition by starting with a block of color. Tear or cut a strip of magazine page about one-third to half the width of the postcard and glue to the postcard with a glue stick. Trim off any excess paper. (See A.)

2 Add a graphic element using decorative tape. I added two strips of tape (in pink and gold) parallel to the bottom edge and two strips of white tape at a steep angle in the lower corner of the card. Think about juxtaposing hard lines and geometrics with soft and organic shapes or images in your packing tape transfer. Add neon tape for a pop of color and washi tape for a bit of pattern. (See B.)

3 Before placing the packing tape transfers onto the postcard, you can add a stripe or dot or place any other shape of color to the back of the transfer with tape or bits of paper. I added two white office dot stickers to highlight the animal faces. Use this technique to add color and interest to your postcard. (See C.)

4 Complete your postcard by adding the packing tape transfers (the animals and the arrows). The antelope will be your focal image, but that doesn't mean it has to be centered. Place a packing tape transfer off center for a more dynamic composition. Continue adding collage elements until you are happy with your overall design. For an extra touch, add a small transfer or bit of decorative tape to the other side of the postcard. Burnish with a bone folder. Add a stamp and pop in the mail! (See D.)

TIP

If your packing tape isn't sticking, use a glue stick or use more tape on top to keep it in place. If you are using tape, make it a design element!

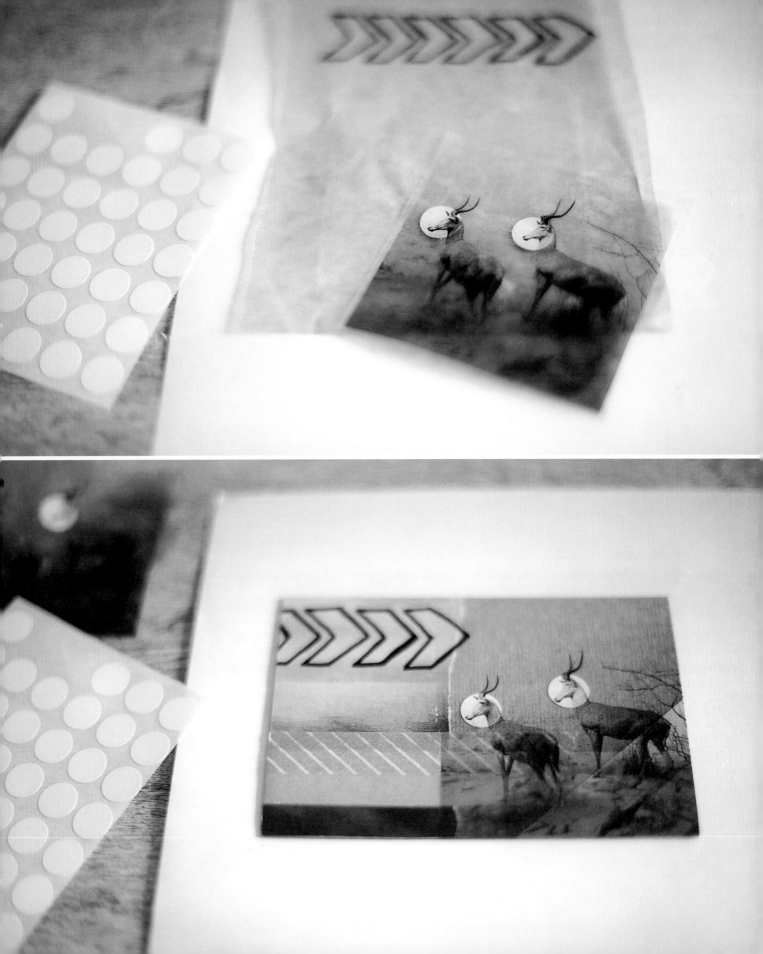

Fauxlaroids

With the ease and prevalence of smart phone photography, nearly everyone has a collection of pictures that are worth saving but might not be suitable for framing. Turn those shots into fun Polaroid-inspired prints to hang on the wall or tuck into a gift. These images can be dreamy and vintage inspired, making them a cheap and creative way to revive the retro feel of a Polaroid.

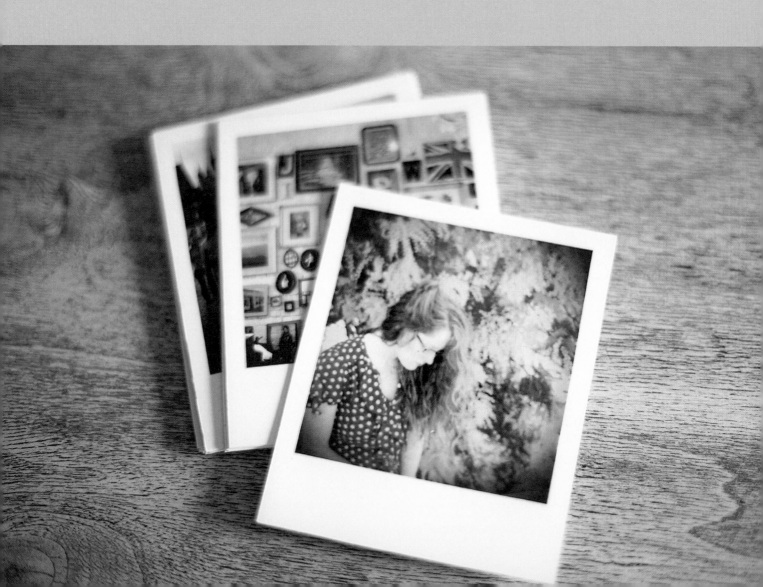

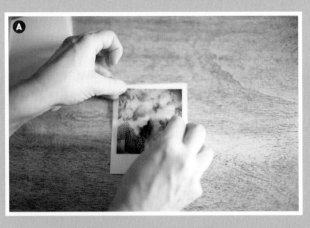

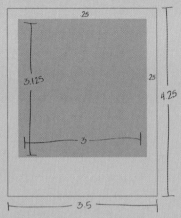

Place the transfer onto the cardstock. Leave a border of 1/4 inch (6 mm) from the top and left and right sides and a wider 7/8 inch (2.2 cm) border at the bottom. (You can approximate the height of the bottom edge to resemble a Polaroid image.) Press the packing tape transfer down firmly to create your fauxlaroid. If the transfer doesn't stick in places, use a dab of glue stick to adhere. (See A and B.)

✂ MATERIALS

- ✔ Method: Packing Tape Transfer (see page 20)
- ✔ packing tape transfer cut down to Polaroid image dimensions: 3" wide x 3 1/8" high (7.6 x 7.9 cm)
- ✔ white matte cardstock cut down to Polaroid frame dimensions: 3 1/2" wide x 4 1/4" high (8.9 x 10.8 cm)
- ✔ glue stick

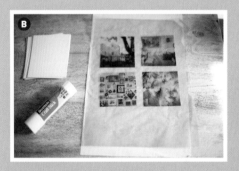

💬 CONSIDERATIONS

Hang fauxlaroids onto a string with clothespins for instant décor. These would be wonderful in a kid's room, on a wall for a quick seasonal design change, or for festive party décor.

TIP

You can make a transfer on 5 or 6 inch (12.7 or 15.2 cm) wide tape and cut down to Polaroid size or line up two strips of regular-width packing tape to create your fauxlaroid.

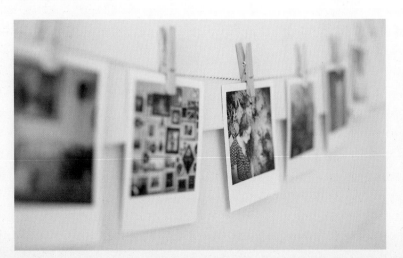

Photo Sur Bois

I love objects. A photo on paper can be beautiful, but an image on wood has a substance and weight that is so seductive. You can use this method to create a vintage look or modern feel. The warmth of the wood gives another layer to an image, adding depth and dimension.

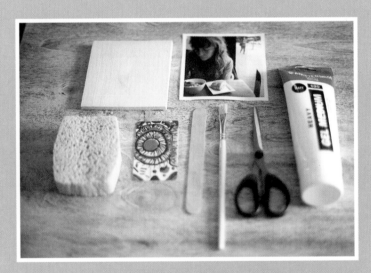

✂ MATERIALS

- Method: Gel Skin Medium Transfer (see page 26)
- soft-bristled brush
- unfinished light wooden plaque with smooth surface
- gel medium
- black-and-white or color photocopy cut to the size of your wooden plaque
- burnishing tool, library card, or wooden craft stick
- sponge and water
- cooking oil (optional)
- paper towel (optional)

💬 CONSIDERATIONS

For a mixed-media piece, add acrylic paint or washi tape to the edges or surface of the wooden plaque to highlight details in the image. Use this method on wooden blocks of various shapes and sizes to create a collection of paintings for a mantle or foyer.

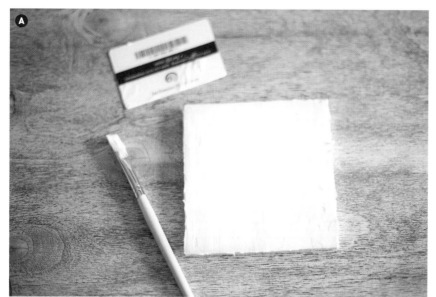

1 Using a soft-bristled brush, coat your wooden plaque with an even layer of gel medium. This layer should be thick enough so you don't see any wood through the gel, but not too thick. Place the photocopy face down into the wet gel and press lightly with your fingers. Burnish the image with your fingers to make even contact with the gel. It is important not to press too hard or you risk pushing out the gel medium and the image won't transfer. Use a library card or an old credit card to burnish to get even, consistent pressure. Let dry completely or overnight. (See A.)

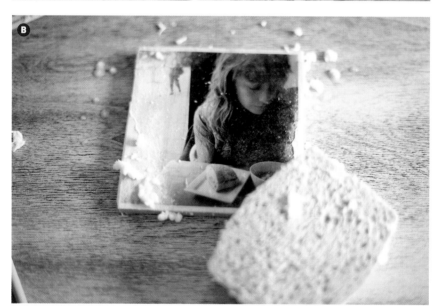

2 Once completely dry, add water with a sponge or with your hands and gently rub away the paper backing until the image is revealed. Continue adding small amounts of water and gently rubbing away paper pulp with your fingers or sponge until all the paper fibers are gone. (See B.)

3 Once the transfer is dry, you may see leftover fine fibers. (see C.) Rub a drop of cooking oil onto the surface of the transfer with a paper towel and buff away to a satin shine.

Tip

This transfer can go awry if you don't let it dry completely or if the gel coat is too thin. If there are still a few paper fibers left but you risk rubbing away the image, let the piece dry completely and then rub a little oil on the fibers to make them disappear.

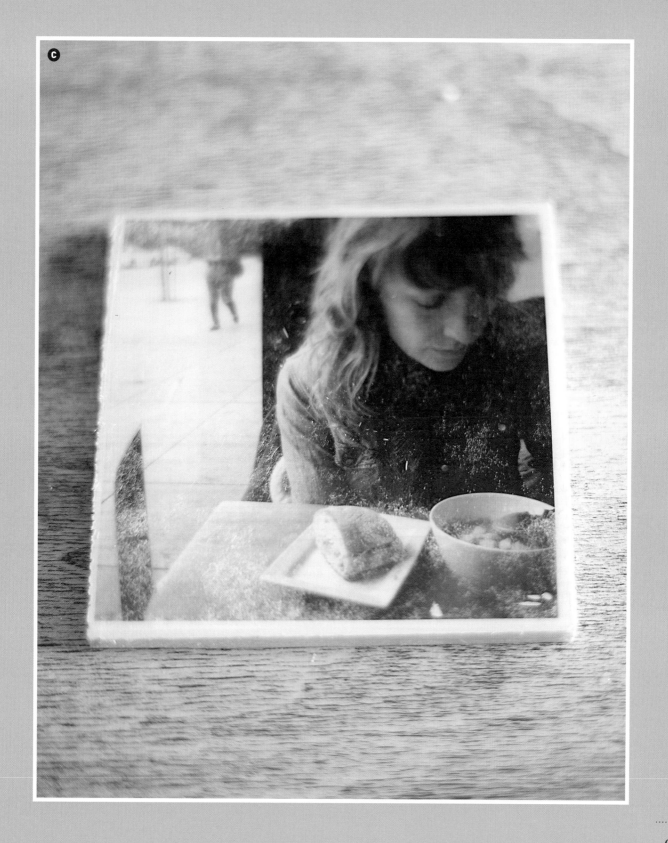

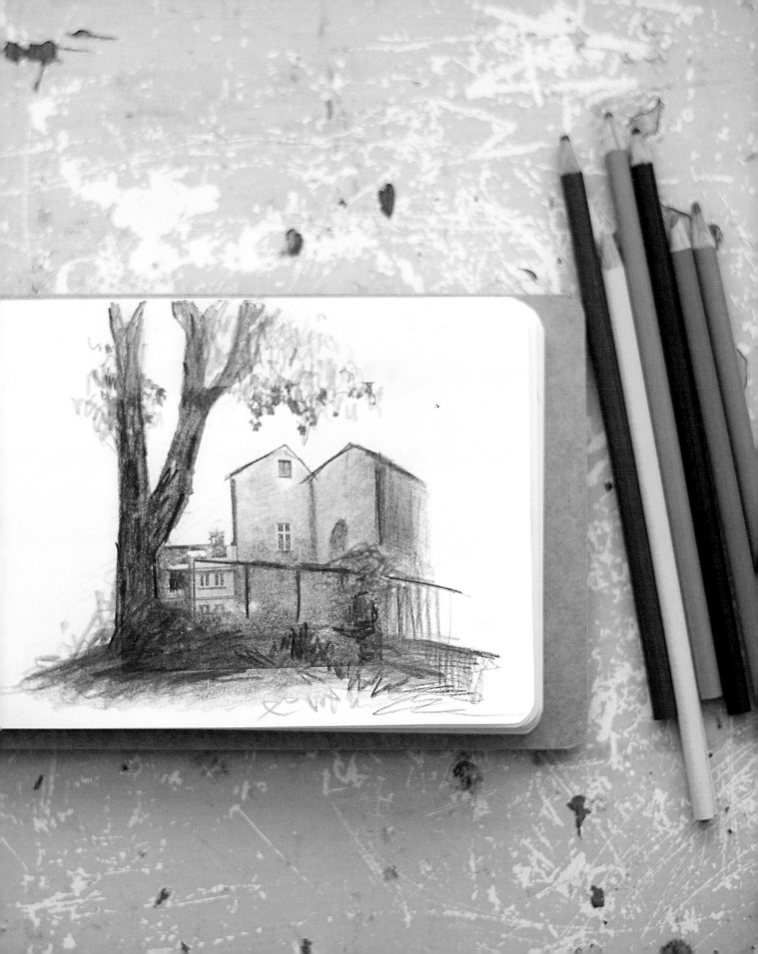

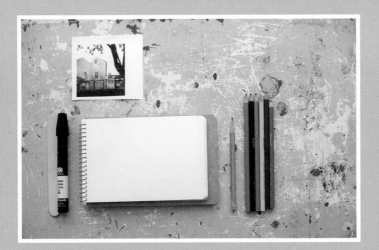

Enhanced Sketching

Attempting to sketch people or places can be intimidating. Image transfers are a great way to start a sketch. Begin with a transfer and build on the image with various mediums. Can't draw? No problem. Embellish a transferred image and make it your own.

✂ MATERIALS

- ✔ Method: Blender Pen Transfer (see page 22)
- ✔ black-and-white photocopy
- ✔ sketchbook
- ✔ blender pen
- ✔ bone folder or burnishing tool
- ✔ graphite pencil
- ✔ colored pencils

💬 CONSIDERATIONS

Use this technique on a fine-grain fabric to create a mixed-media painting. Substitute colored pencils for acrylic paint when using fabric. Hang your artwork from a piece of driftwood or branch for an unexpected presentation.

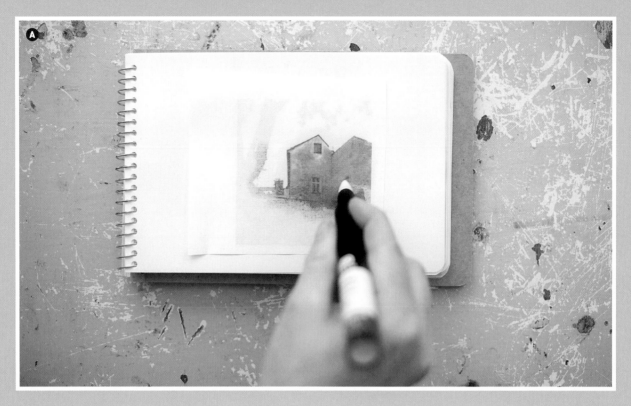

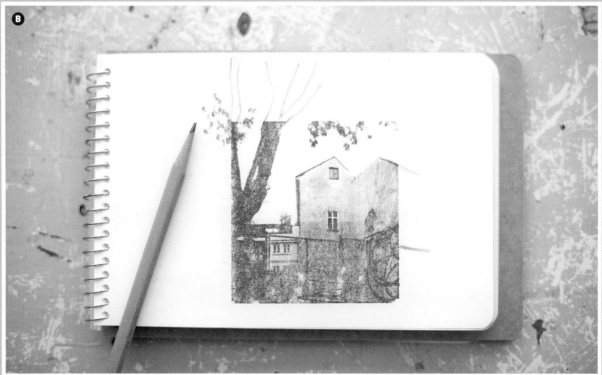

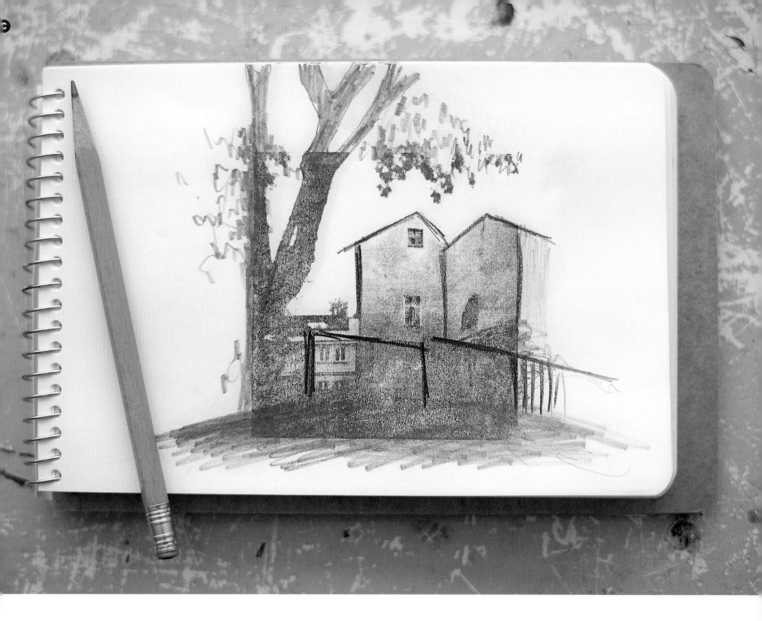

1 Place the photocopy face down onto the sketchbook page. "Color" the back of the photocopy with the blender pen. Without moving the photocopy, burnish completely with a bone folder. Lift a corner to ensure you've transferred the image evenly. Repeat steps as necessary and remove the photocopy once you are satisfied. (See A.)

2 Using a graphite pencil, extend lines from your image onto the surrounding page. It's easy to start with obvious lines such as buildings, horizon lines, and branches. (See B.)

3 Fill in the sketch with texture using graphite pencil. Continue to build on the existing image by adding color, starting with light shades first. You can take this as far as you like, using the transfer as a base and creating your own composition from there. Unlike collage, which leaves an edge, a transfer is seamless, which really allows you to make this sketch entirely your own. (See C.)

Twinkling Landscape

Add a photo to a simple glass votive to create a dreamy and atmospheric image lit from within.

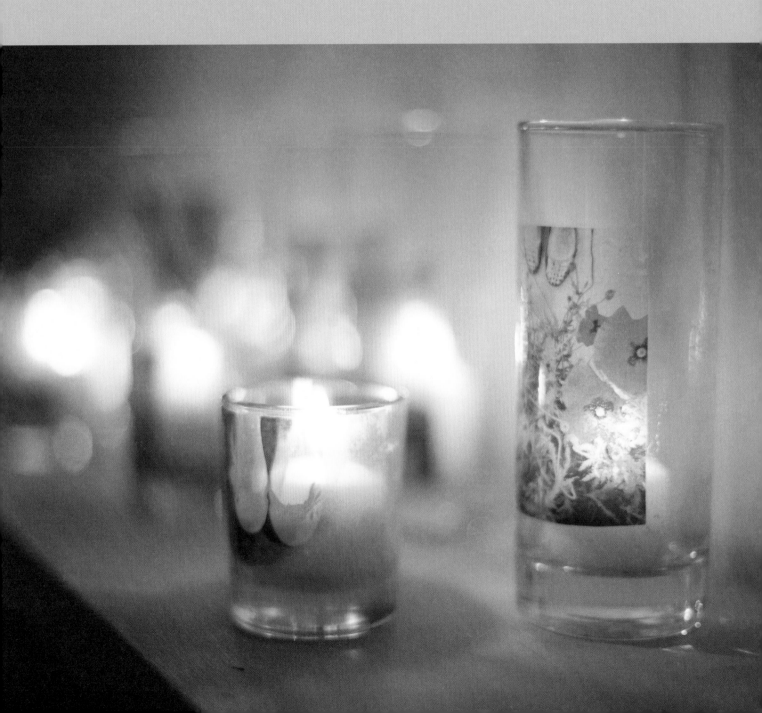

TIP

Packing tape transfers with lots of light, white, or open space, especially images of skin, can look a little ghostly when lit. Opt for landscapes, architectural images, and high-contrast black-and-white images or bright colors, which look best when lit. Votives with straight sides work best.

1 Place your packing tape transfer onto the outer surface of the glass votive. Align and burnish out any bubbles with your fingers. Repeat this step for multiple votives. (See A.)

2 Place the candle inside the votive and watch your transfer light up. (See B.)

✂ MATERIALS

- ✔ Method: Packing Tape Transfer (see page 20)
- ✔ glass votive holders with straight sides in various sizes
- ✔ bone folder or burnishing tool
- ✔ wax votive candles in various sizes

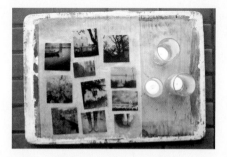

🖋 CONSIDERATIONS

Place a grouping of votives on a mantle for instant décor or create a tablescape for an intimate dinner.

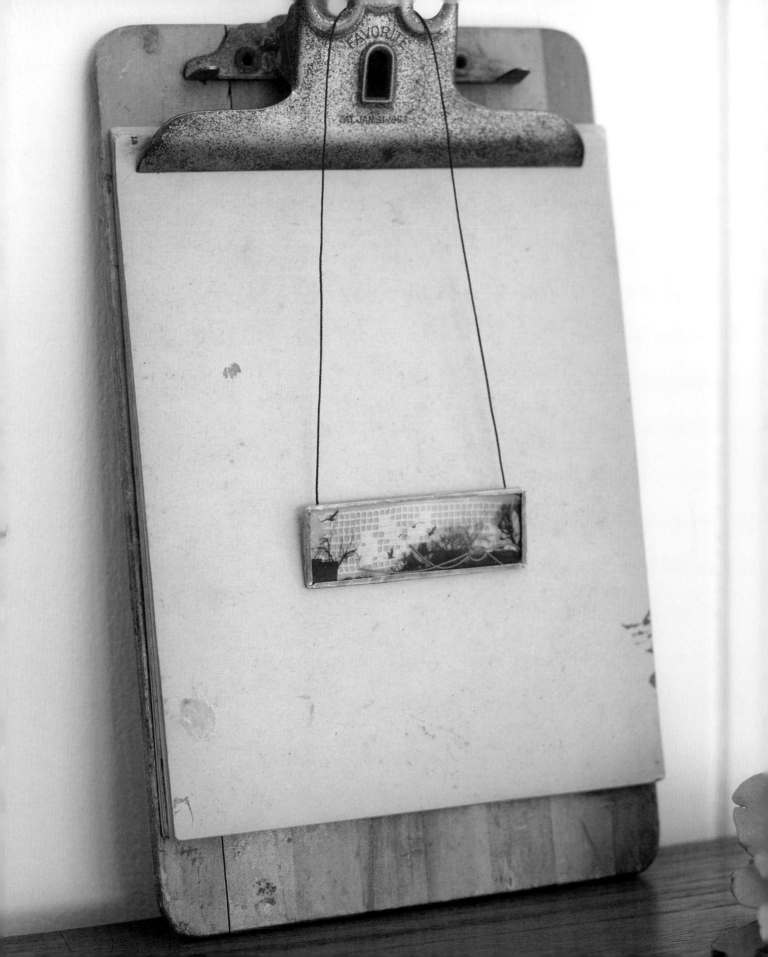

Microscope Slide Necklace

Create a unique pendant necklace with microscope slides and found imagery. Layer in dried botanicals, thread, and fibers or other findings for a little collection you can carry with you.

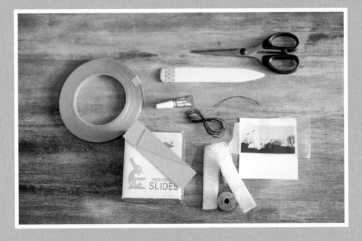

- ✔ Method: Packing Tape Transfer (see page 20)
- ✔ scissors or craft knife
- ✔ small piece of book board or lightweight cardboard
- ✔ microscope slide
- ✔ packing tape transfer
- ✔ collage materials or flat ephemera such as a dried leaf or flower, lace, or thread
- ✔ patterned paper
- ✔ copper tape, 1/4" (6 mm) wide
- ✔ bone folder or burnishing tool
- ✔ leather cord, twine, or ribbon
- ✔ glue

💬 **CONSIDERATIONS**

Use family photos, kids' drawings, or simple sketches for a variation on this charming necklace. Scraps of embroidery or vintage textiles are also great to use. Create an ornament by using a shorter cord.

PURPOSEFUL PLAY

049

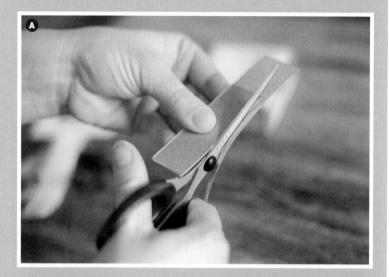

1 Create a backing by cutting book board or light cardboard to match the size of the microscope slide, rounding the corners slightly, if needed. (See A.)

2 Place the packing tape transfer onto the back of the microscope slide, which will then become sandwiched inside the pendant. Trim away any excess packing tape transfer and set aside. (See B.)

3 Compose any elements you wish to trap in the pendant. I like using bits of thread, lace, or fabric, but you can also use dried botanical elements, patterned paper, or anything that lies flat. Occasionally, place the slide over the elements to check the composition. You can replace the packing tape transfer or any element in your collage during this composition process. Trim off any excess. (See C.)

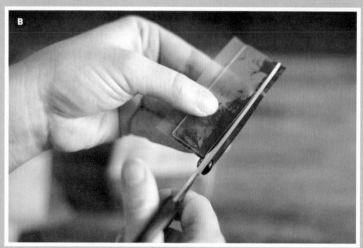

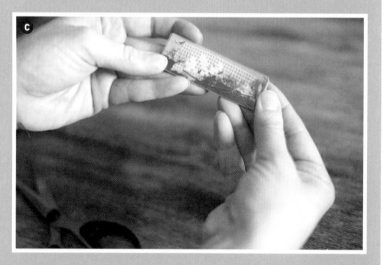

TIP

Glue a scrap of fabric or leather to the back of the completed pendant for a finishing touch.

4 Once you are happy with the composition, place the slide on top of the backing. You will use the copper tape to seal together the pendant layers and create a decorative border. Start by pulling out a length of tape from the roll, about 12 inches (30.5 cm). Pinching together the slide and backing, roll the pendant along the length of the copper tape. Working along the side edge, place the pendant down along the copper tape so that the copper tape extends evenly on both the left and the right sides. When you get back to your starting point, overlap the copper tape about 1/8 inch (3 mm) and cut. Burnish the tape lightly with your finger the whole way around the slide and backing edge. (See D.)

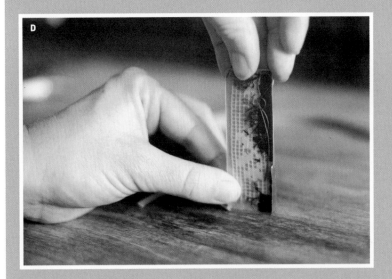

5 Continue to pinch together the slide and backing. Holding the edges, carefully place the tape down onto the face of the slide. Using a bone folder, start with the short edges and burnish down all along the short edge, creating a mitered corner. (See E.)

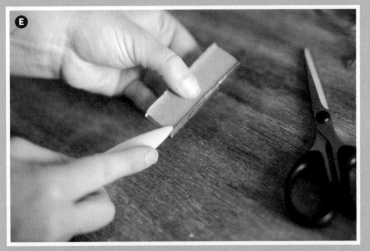

6 Burnish down the long side and fold over the mitered corner, making a clean frame.

7 Repeat on the back.

8 Determine the cord length for your necklace. Place a dot of glue on the left and right sides of the back of the pendant and place the cord in the glue. Allow to dry before wearing. (See F.)

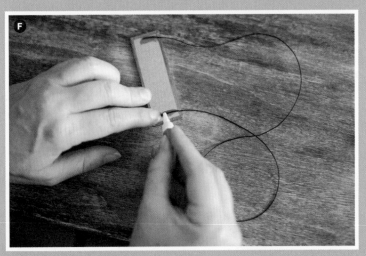

Photo on Canvas

People often want to transfer their photos onto canvas. You can use gel medium or an acrylic paint method for this; they both look awesome. Often, the gel will give you a cleaner look and the acrylic can have small imperfections, giving you a more distressed appearance.

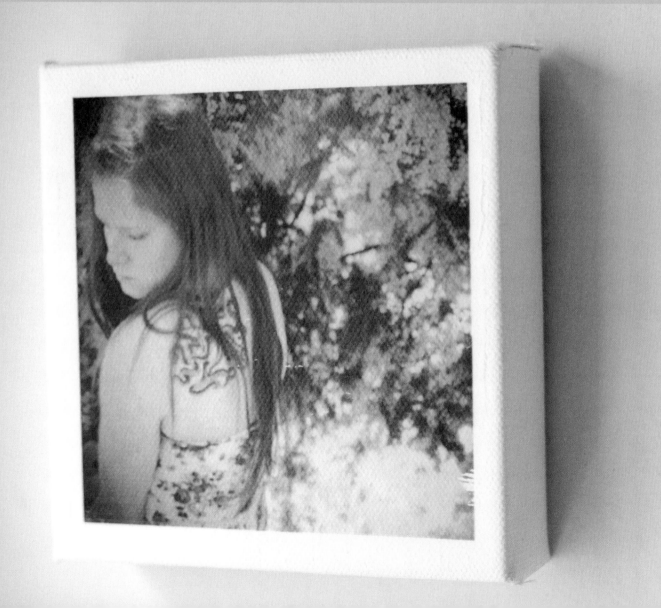

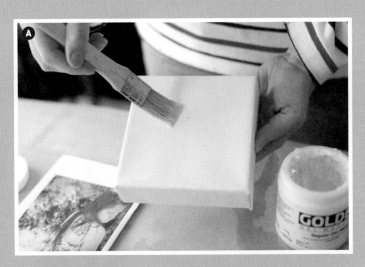

1 Brush on an even layer of gel over the surface of the canvas. (See A.)

2 Place the photocopy face down into the wet gel and burnish with your finger or a library card. Allow to dry completely!

3 Once dry, gently remove the paper pulp with a damp sponge, using circular motions. Add water and remove paper pills as necessary until the image is revealed. (See B.)

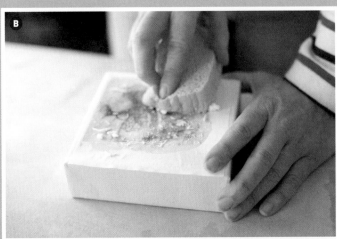

TIP

If any tiny fibers are left once the image is dry, you can add a little cooking oil to make them disappear.

✂ MATERIALS

- ✔ Method: Gel Skin Medium Transfer (see page 26)
- ✔ brush
- ✔ gel medium
- ✔ canvas with wooden cradle (I like the look of a deep cradle)
- ✔ color photocopy (reversed)
- ✔ library card or credit card
- ✔ sponge and water

💬 CONSIDERATIONS

This is a great method to use as the base for a painting. Whether you are using gel or acrylic paint, other media can be layered on top of this transfer easily, making it a great first layer to any mixed-media piece.

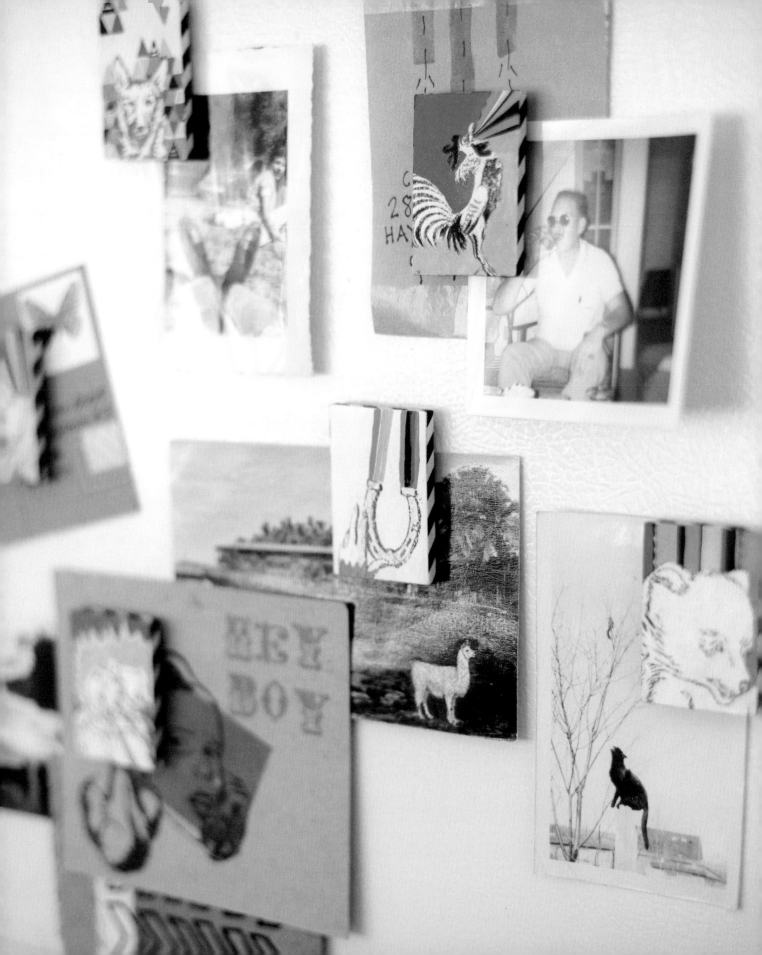

Modern Magnets

Make a set of magnets to add personality and punch to your fridge, office, or filing cabinet. A gift of magnets means a promise of postcards ... so make a packing tape postcard (see page 33) to go with them!

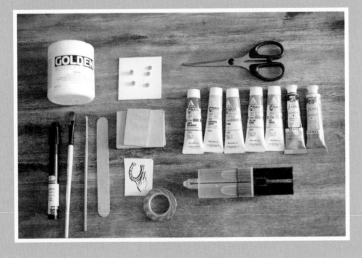

✂ MATERIALS

- ✔ Method: Blender Pen Transfer (see page 22)
- ✔ paintbrush
- ✔ wooden shapes
- ✔ white gesso or light-colored acrylic paint
- ✔ black-and-white photocopy
- ✔ blender pen
- ✔ burnishing tool
- ✔ two-part epoxy
- ✔ toothpick
- ✔ mighty magnets or other small strong magnet
- ✔ washi tape
- ✔ craft paint or gouache

💬 CONSIDERATIONS

This is also a great project to do with photos. Use color or black-and-white photocopies and the acrylic paint transfer method (see page 28) to create wooden photo magnets.

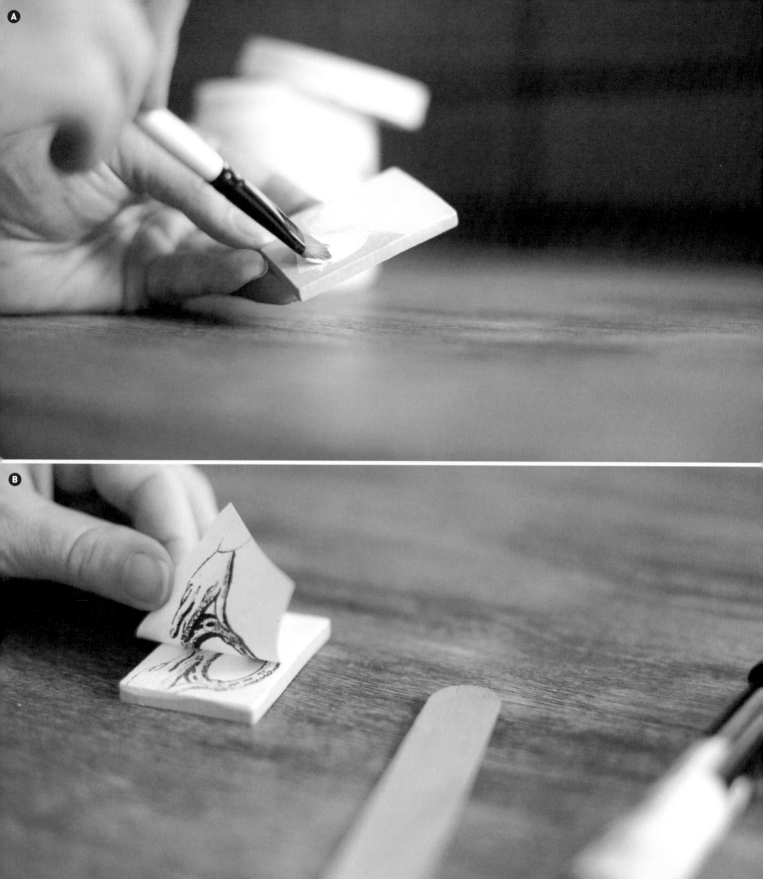

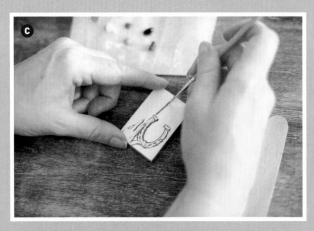

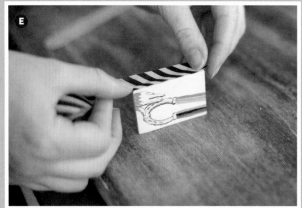

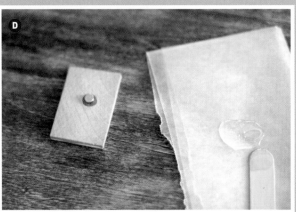

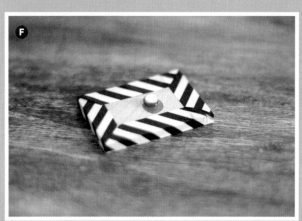

1 Paint the wooden shapes with white gesso or light-colored acrylic paint. Set aside to dry. (See A.)

2 Place the photocopy face down onto the dry painted wooden shape. "Color" the back of the photocopy with a blender pen and burnish until the image is transferred. Repeat for each shape. (See B.)

3 Using acrylic paint, add detail to your transfer. Create a background by painting geometric shapes or highlight areas with bright pops of color. Set aside to dry. (See C.)

4 Mix the two-part epoxy and with a toothpick, apply a dab of the epoxy on the back of each wooden shape. Place the magnet into the wet epoxy. Allow to dry according to the manufacturer's instructions. Don't use the magnet until the epoxy is dry. (See D.)

5 Finish the edges with washi tape for an extra pop of pattern. (See E and F.)

TIP

You can use regular craft magnets and hot glue or craft glue instead of epoxy, but you do risk pulling the wooden shape away from the magnet if the glue is not strong enough.

Bohemian Fabric Bunting

This sweet little bunting incorporates some of my favorite elements: soft, ethereal images, natural muslin, and a bit of hand stitching. The red thread and shell buttons add just the right texture, giving this piece a dreamy quality, as if created from a lifetime of half-remembered moments.

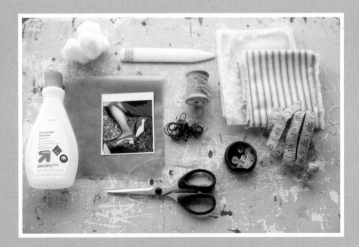

✂ MATERIALS

- ✔ Method: Acetone Transfer (see page 24)
- ✔ color photocopies
- ✔ scissors
- ✔ 1/2 yard (45.7 cm) muslin
- ✔ 1/4 yard (23 cm) red and white ticking (optional)
- ✔ acetone
- ✔ cotton balls
- ✔ burnishing tool
- ✔ red thread
- ✔ large-eye sewing needle
- ✔ various buttons
- ✔ twine

PURPOSEFUL PLAY

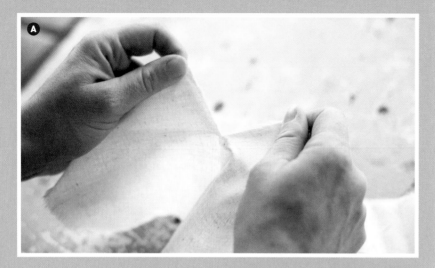

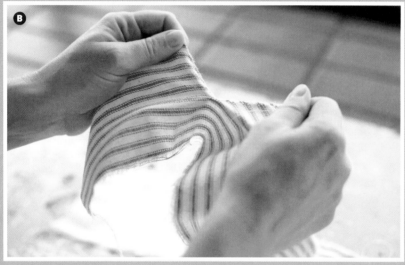

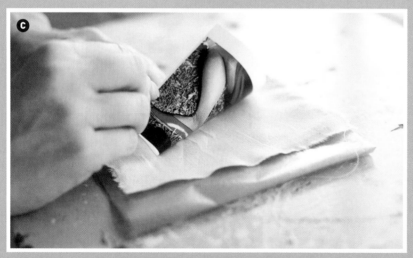

1 Determine the photocopy size and tear muslin fabric flags so that you have about a 1/2 inch (1.3 cm) border on the top and side. Leave a larger border at the bottom if you want to add stitched or button embellishments. I love the look of a torn edge. To tear your flag, first snip a small cut where you want to tear and then firmly tear from the left and the right with both hands, as if to open a big book. Tear flags for all of your photos. (See A.)

2 Tear the striped flags in the same way. Determine whether you want your stripes to run vertically or horizontally and tear accordingly. (See B.)

3 For each muslin flag, create an acetone image transfer (see page 24). Place the photocopy face down onto the muslin flag. Be sure to center the image from the left, right, and top edges, leaving a larger margin at the bottom for embellishment. Dab a cotton ball saturated in acetone over the entire photocopy back. (See C.)

4 Burnish vigorously, checking as you go. Repeat until the image is transferred. Repeat for each muslin flag. (See D.)

5 Cut a V into the red striped flags by folding in half. Starting at the center of the fold about 2 inches (5 cm) up, cut at an angle down to the unfolded corner edge. Repeat for each striped flag. (See E.)

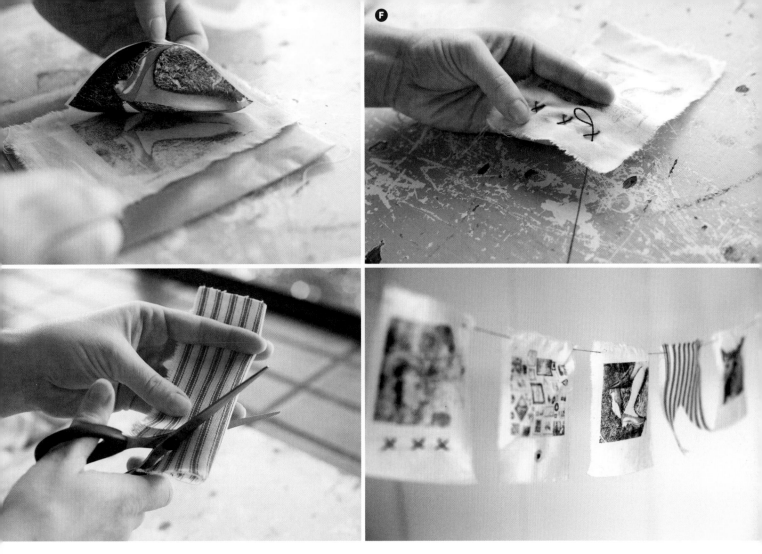

6 Arrange all the flags, alternating between stripes and images. You can do this organically as you sew or more methodically for a repeating pattern.

7 Decide which flags to embellish. Use embroidery floss to create stitched Xs or sew on buttons. (See F.)

8 Sew the flag in place by starting with the last flag. Using a length of twine that will accommodate all your flags (for 12 flags, my twine was about 6 feet [183 cm]), string on the first flag by coming in from the front about 1/4 inch (6 mm) from the left, top edge. Sew through to the back and bring the needle from back to front 1/4 inch (6 mm) from the right and top edge. This will conceal your twine on the back of the flag, but you could do the opposite if using a baker's twine or other decorative thread. Bring the flag all the way to the end of the twine, leaving about a 6 inch (15.2 cm) tail. Secure the flag in place by wrapping the thread over the right edge and coming up next to the hole you just sewed through. Leave about 1 inch (2.5 cm) between flags and continue stringing on all the flags.

TIP

Acetone transfers are soft and ethereal. This project has a lovely vintage quality, but if you want something more graphic, you can use a gel medium (see page 26) or an acrylic transfer method (see page 28) to create the images on the flags.

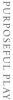

Craft Jar Labels

Make custom labels for your craft supplies, homemade goodies, and gifts. Organize your life with these graphic and easy-to-make labels.

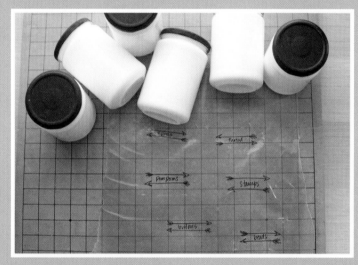

TIP

If the packing tape needs a bit of extra stick, lightly apply a glue stick to adhere to the surface.

1 Create a packing tape transfer (see page 20) using photocopies of your own drawings or ones provided in the book.

2 Trim the transfer to the appropriate shape or size so it fits on your jar.

3 Place the transfer onto the jar to create a personalized label for organization or gift giving. (See A.)

✂ MATERIALS

✔ Method: Packing Tape Transfer (see page 20)

✔ packing tape transfers of drawn labels

✔ scissors

✔ glass jar or container with a smooth surface containing your collection of goodies

✔ glue stick (optional)

● CONSIDERATIONS

Use hand-drawn lettering for one-of-kind labels that are entirely your own. Add doodles and sketches for special occasions and holidays. These little labels are great for homemade jams or pickles or even for organizing your pantry!

PURPOSEFUL PLAY

063

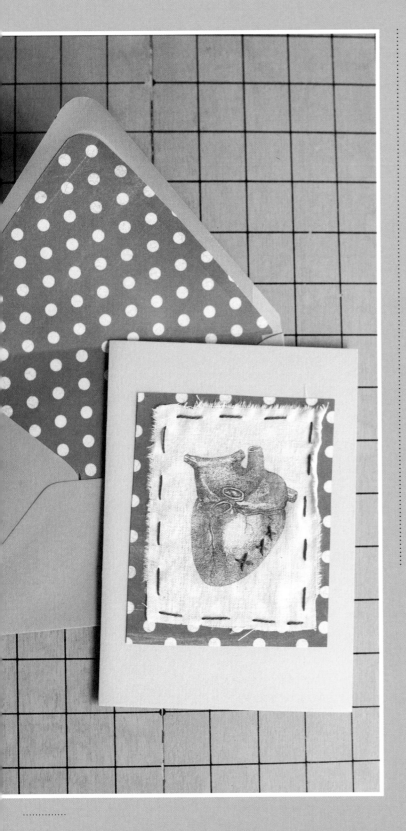

Layered
Love Note

Layering paper and fabric with a bit of hand stitching has got to be one of my favorite things. When I give a love note, I like it to be a little outside the traditional realm of hearts, which is why the anatomical heart is so appealing. This technique started as a pamphlet stitch book and has become one of my favorite ways to transform a basic folded card into a sweet little mixed-media piece.

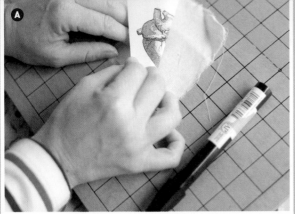

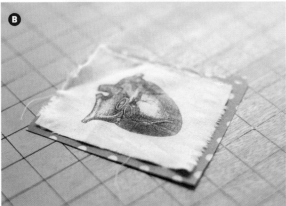

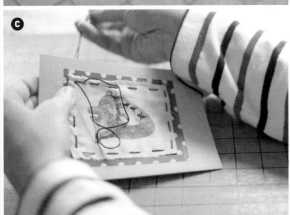

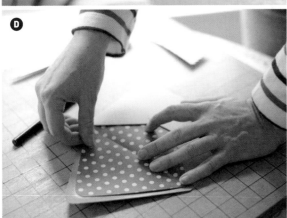

1 Tear a piece of muslin just larger than your photocopied image. Make sure you still have room for your patterned paper border and card.

2 Place the photocopy face down on the fabric. "Color" the back of the photocopy with the blender pen and burnish. Repeat until the image is transferred. (See A.)

3 Cut a piece of patterned paper just slightly larger than the fabric scrap. (See B.)

4 Layer the fabric scrap and patterned paper on the face of the card and hand stitch in place using a running stitch. Your stitches will show up on the inside, which I like. But you could also cover this with another piece of patterned or solid color paper using a glue stick. (See C.)

5 Create an envelope liner by tracing your envelope lapel onto the wrong side of the second sheet of patterned paper. Cut about 1/4 inch (6 mm) inside the line. Place the insert into the envelope and glue in place. (See D.)

✂ MATERIALS

- Method: Blender Pen Transfer (see page 22)
- scrap of muslin or cotton
- black-and-white photocopy
- blender pen
- burnishing tool
- scissors
- 2 pieces of patterned paper
- A2 card and envelope
- heavyweight red thread
- sewing needle with large eye
- glue stick

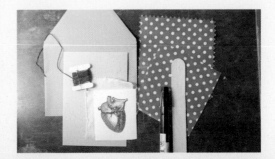

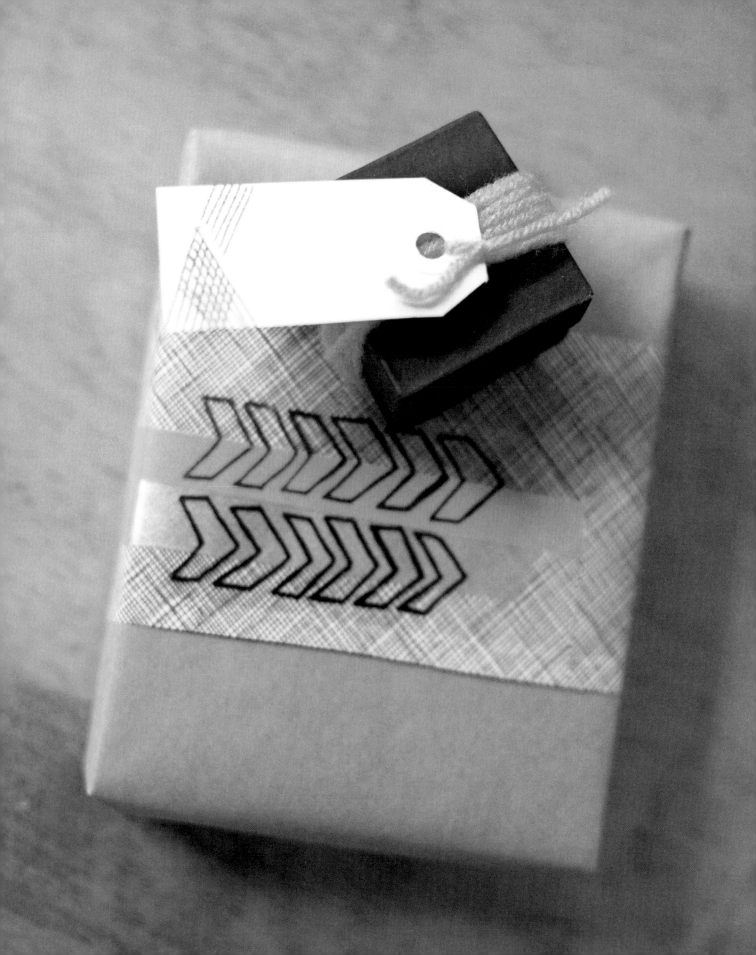

Fabulous Gift Wrap

I love giving gifts. For me, the presentation is where the story starts; it is as important as the gift itself. Use unexpected materials or vintage finds along with handmade packing tape transfers (see page 20) to add an extra special touch that tells your recipient this gift is just for her.

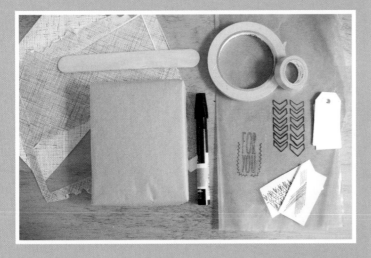

✂ MATERIALS

- ✔ Methods: Packing Tape Transfer (see page 20) and Blender Pen Transfer (see page 22)
- ✔ wrapped gift
- ✔ envelope (with a security pattern on the inside, such as those sent with bills)
- ✔ scissors
- ✔ double-sided tape, washi tape, or decorative tape
- ✔ packing tape transfers
- ✔ black-and-white photocopies of various words, phrases, or sketches (reverse if using words)
- ✔ mailing tag or other gift tag
- ✔ blender pen
- ✔ burnishing tool

🗨 CONSIDERATIONS

Print thumbnails of your favorite pictures to create a filmstrip to use as a package topper. You can also create text by using your computer. I typed "celebrate" in Arial Black and then sprinkled the back of the tape with glitter to create a bold message with a bit of sparkle. Create tags to use as ornaments on a tree, place cards, or escort cards at your next party or event.

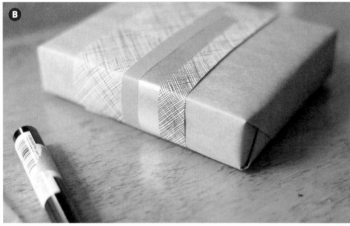

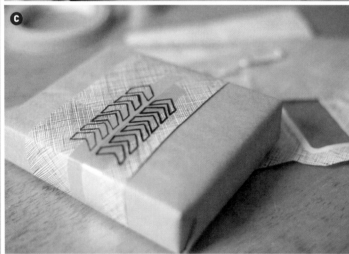

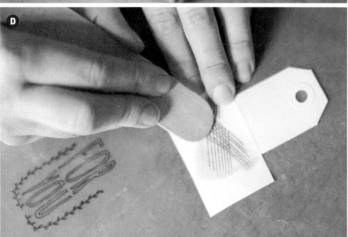

1 Wrap the gift in a solid paper. I love to use kraft paper, but you can use any solid you like. If you're planning on placing the tape directly on the wrapped gift, then the paper needs to be light in color. You can also wrap your gift in a patterned paper and then add a bellyband in a coordinating solid.

2 To make a patterned bellyband on a small gift, I use the inside of the envelopes my utility bills come in. Take a peek into your next bundle of mail, and you'll discover tiny prints in black, white, blue, and green. Remove the window and cut the envelope along its length to create a long strip. Add this to your package with double-sided tape or washi tape for a bit of color. (See A.)

3 Add a pop of color with neon or other brightly colored tape. I paired neon pink with silver washi tape. (See B.)

4 Add your packing tape transfer over the decorative tape and bellyband. I chose the bold, graphic arrows, but this could be a transfer of a phrase, a word, or even a high-contrast photo. Because you can see through the tape, you can choose the alignment. Place the tape and burnish lightly with your fingers. (See C.)

5 To create a gift tag, place the photocopy face down on the mailing tag. Color the back with the blender pen and burnish thoroughly. Without moving the photocopy, lift a corner to see how the transfer is taking. Repeat if the image isn't fully transferred. (See D.)

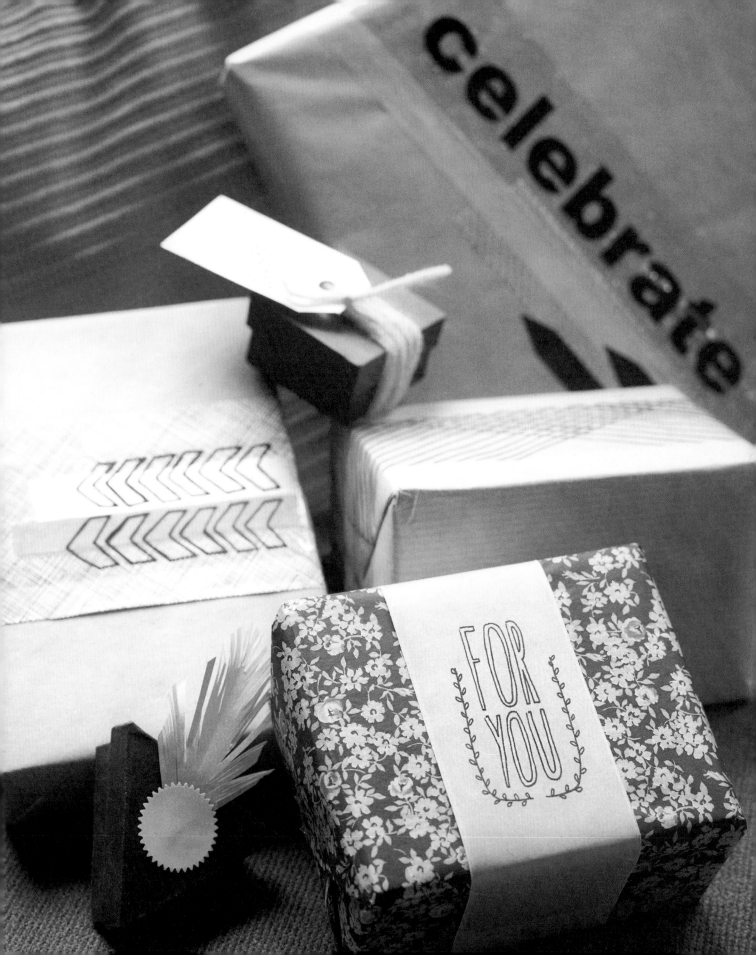

Metallic Photo

Metal and other nonporous surfaces can be hard to transfer onto. Gel medium is one of the best methods to use for a successful transfer. Because gel is translucent, the surface of your metal base will shine through, giving your image great depth and dimension. This method works best with high-contrast black-and-white images. I love transferring vintage images onto metal. I'm inspired by early photographic tintypes. Although I'm partial to portraits, images of clouds, landscapes, and water look beautiful, too. You can also paint on top of the gel surface to add a soft blanket of color.

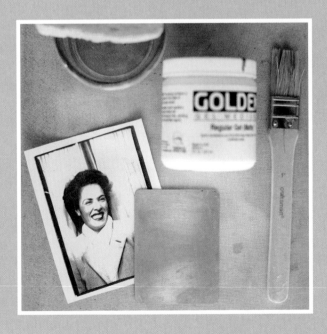

✂ MATERIALS

- Method: Gel Skin Medium Transfer (see page 26)
- piece of metal with a smooth, clean surface
- green scouring pad or cotton ball and rubbing alcohol (optional)
- glue brush
- gel medium
- black-and-white photocopy (reversed)
- sponge and water
- cooking oil (optional)

💬 CONSIDERATIONS

Check the hardware or craft store for interesting and inexpensive pieces of metal. I like to use galvanized sheeting or small metal tags.

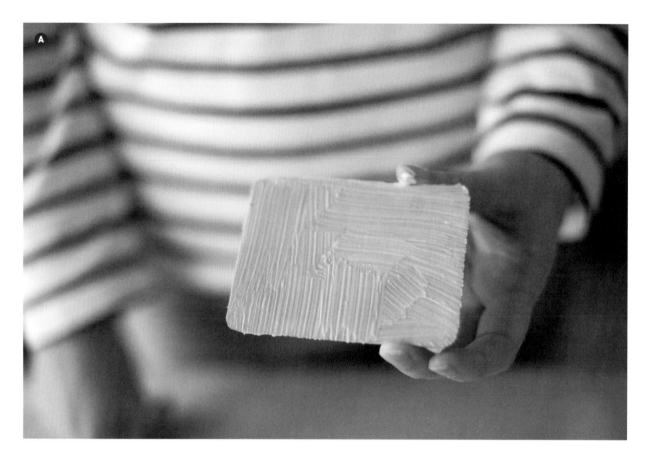

1 Make sure your metal surface is clean of grease. You can lightly buff it with a green scouring pad or use a cotton ball and rubbing alcohol to remove any residue.

2 Brush an even coat of gel medium on the clean, dry surface of the metal. (See A.)

3 Place the photocopy face down into the wet gel and lightly burnish with your fingertips. Allow to completely dry! Drying can take up to several hours. To test, gently peel back a corner of the photocopy. If the gel lifts with the paper, the transfer is not ready. If the paper tears away, then you're good to start the next step.

4 With a damp sponge, gently remove the paper backing using circular motions. Add small amounts of water as necessary and remove the paper pills as you go. (See B.) Continue until all the paper backing is removed.

TIP

If you've removed as much paper as possible but still have a few fibers and risk damaging your image with further rubbing, add a bit of cooking oil onto the surface and buff for a satin shine.

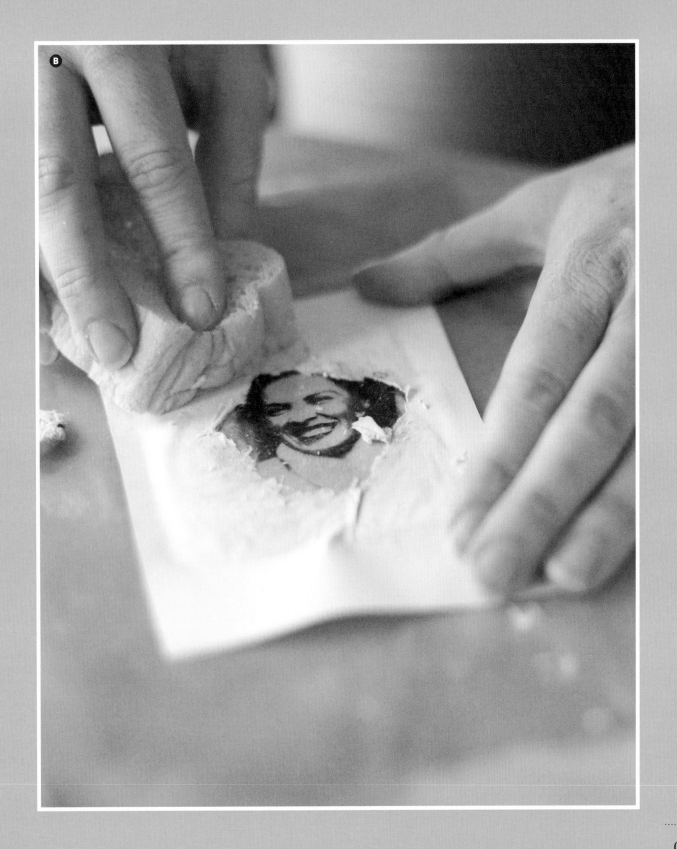

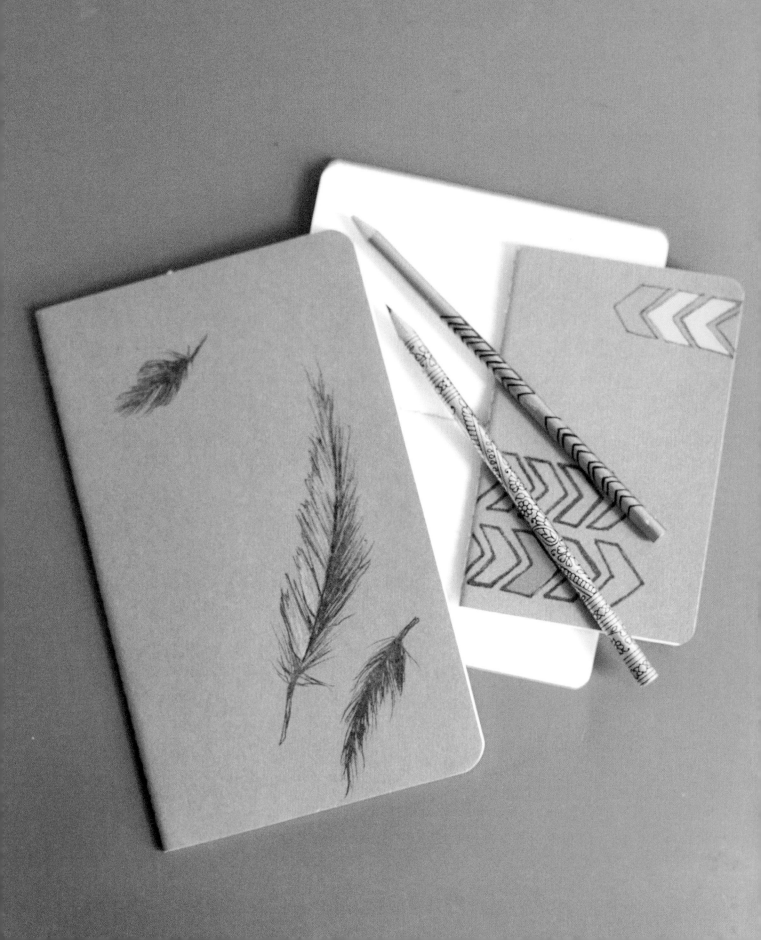

Savvy Sketchbook

There are a ton of sketchbooks out there, and they make a great gift for an artist, a writer, or a list maker or note taker. It's a really special thing to receive a customized sketchbook. Take a standard Moleskine and give it your own spin by creating a graphic or image for the cover. You can even add a few small images throughout the blank pages for a nudge of inspiration.

✂ MATERIALS

- ✔ Methods: Packing Tape Transfer (see page 20) and Blender Pen Transfer (see page 22)
- ✔ rounded metallic or bright-colored graphite pencil (preferably one without type on the outside)
- ✔ packing tape transfer
- ✔ scissors
- ✔ flexible measuring tape or piece of string and ruler
- ✔ black-and-white photocopy of feathers or your own drawings (reversed if words)
- ✔ Moleskine or other blank sketchbook with nonglossy cover
- ✔ blender pen
- ✔ bone folder or burnishing tool
- ✔ acrylic paint
- ✔ paintbrush

🗨 CONSIDERATIONS

Clip art of tribal and ethnic patterns make great additions to your sketchbooks.

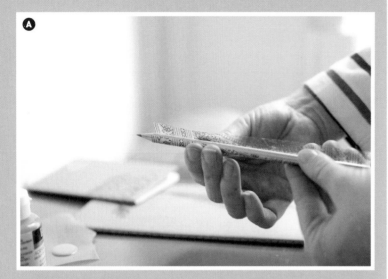

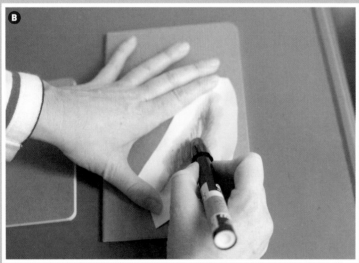

1 For the pencil, create a black-and-white packing tape transfer (see page 20). Cut the transfer down to pencil size. Most pencils are about 7/8 inch (2.2 cm) in circumference and about 7 inches (17.8 cm) long. You can easily measure your pencil by wrapping a bit of thread around the pencil once and measuring that if you don't have a flexible measuring tape. Place the tape onto the pencil and press down until adhered. The packing tape can also be sharpened along with the pencil as you go. (See A.)

2 To create a custom sketchbook cover, place a black-and-white photocopy face down onto the sketchbook cover. If using type, make sure your photocopy is reversed. "Color" the back of the copy with the blender pen and burnish with the bone folder. Continue until your image has transferred completely. You can check by gently lifting a corner to peek and see how you're doing. Repeat "coloring" and burnishing until the image is transferred. (See B.)

3 I love to add a pop of color once my image is transferred. Consider using a metallic or brightly colored acrylic paint to add visual interest or highlight a little detail here and there. I chose a metallic champagne to accent some areas of the feather. (See C.)

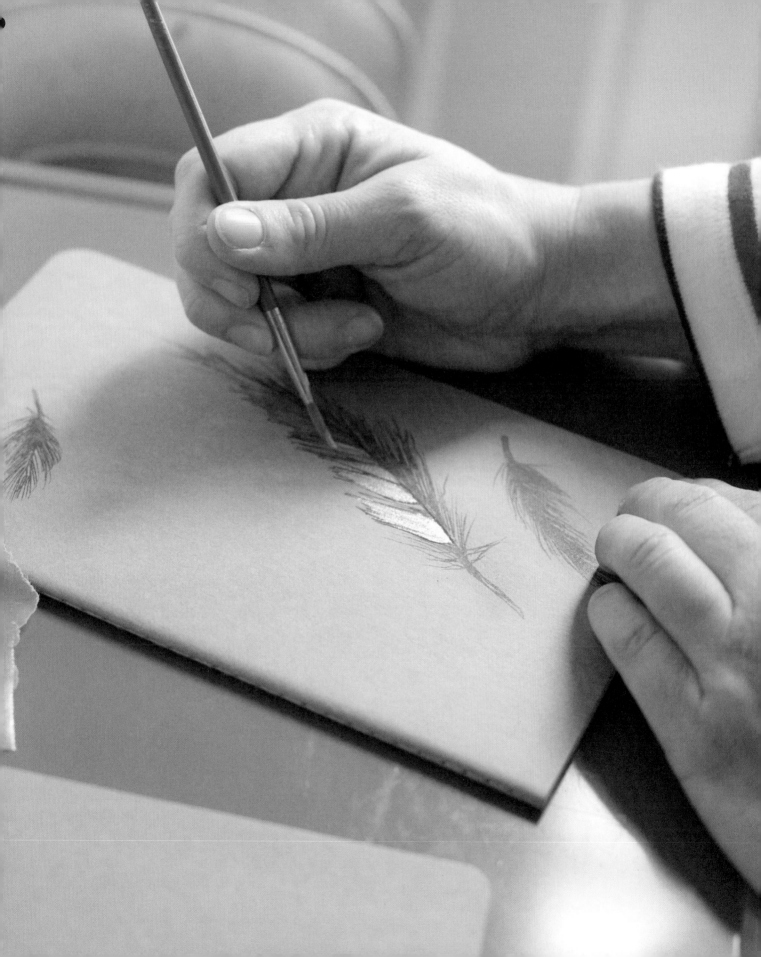

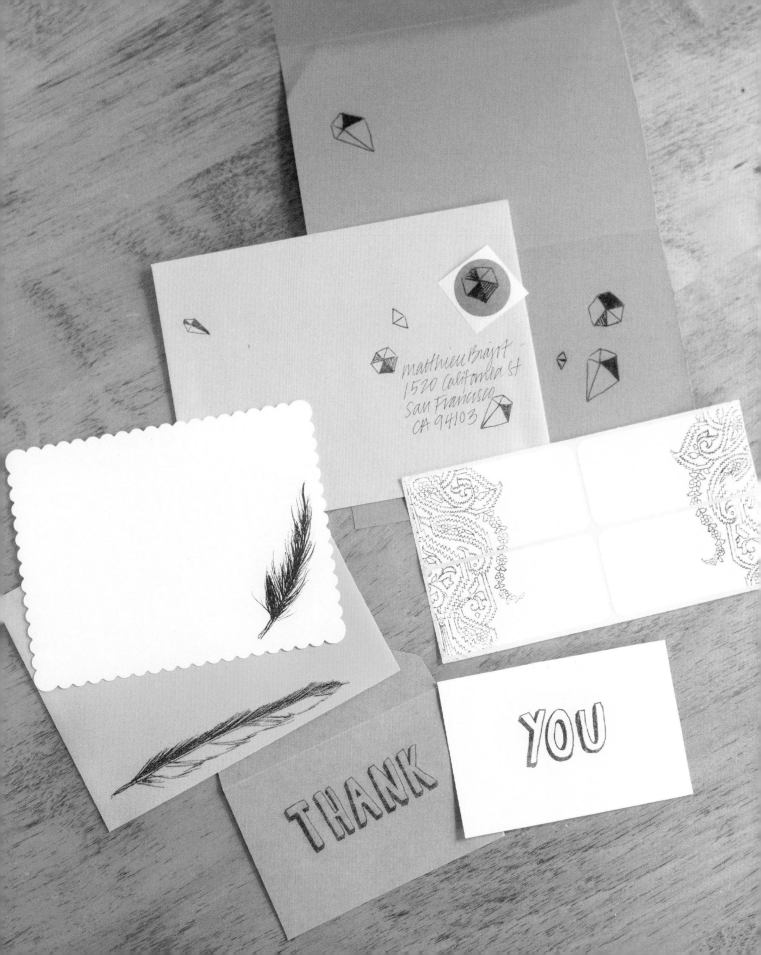

Stationery Suite

Lettering by Matthieu Brajot

Make a suite of custom stationery by adding design elements to everyday office supplies. I most often use image transfer techniques for making punchy, quick correspondence. I love getting mail, and I love sending it, too! Use these methods as a starting point for adding flair to ordinary materials and then fly off in your own direction. The sky is the limit!

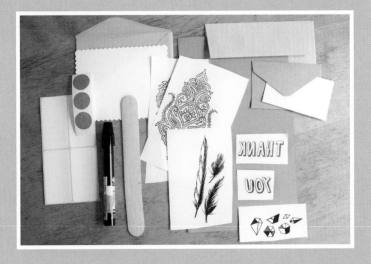

✂ MATERIALS

- Method: Blender Pen Transfer (see page 22)
- black-and-white photocopies
- various pieces of blank stationery (I used a flat A2 and envelope, a flat 4 bar card and envelope, and a sheet of paper and matching envelope)
- blender pen
- burnishing tool
- office labels, white or other solid color (without a slick surface, no metallic)

🗩 CONSIDERATIONS

Create little sets of stationery as gifts for a friend moving away, baby or bridal showers, birthday parties, or tea parties (my favorite).

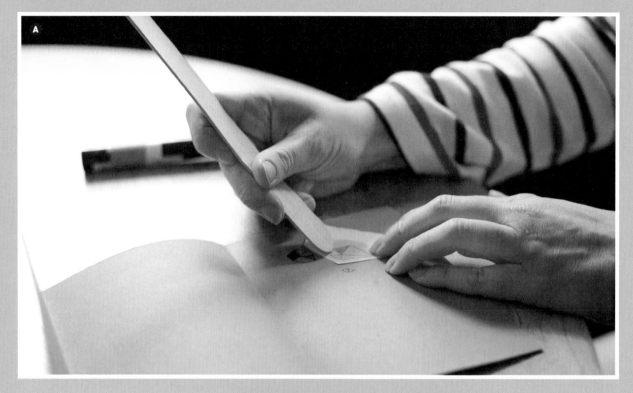

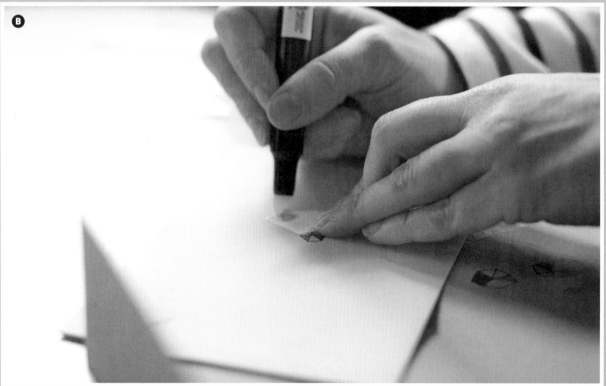

1 Add small graphics to a sheet of writing paper. I love gray paper because it's a neutral that I can pair with a metallic for a glam look or with a neon for a contemporary feel. Place the photocopy face down onto the sheet of stationery and "color" the back with the blender pen. Without shifting the photocopy, burnish until the image is transferred. Continue transferring small graphics scattered along the page. I like to do small groupings of odd numbers in various sizes. (See A.)

2 Create a matching envelope by placing a few diamonds on the front of the envelope or on the lapel. Place the photocopy face down onto the sheet of paper and "color" the back with the blender pen. Without shifting the photocopy, burnish until the image is transferred. Sprinkle these diamond graphics over the envelope for a hint of what's inside! (See B.)

3 To make a set of labels for mailing, organizing, or using as stickers, choose a large image or graphic. I like to transfer a single image over several stickers at once. This allows the image to bleed off the label, giving it a professionally designed look. (See C.)

4 I love the look of a hand-drawn graphic. Make a Thank You card with a simple transfer. Place a reversed photocopy face down onto the flat card and "color" the back with the blender pen. Without shifting the photocopy, burnish

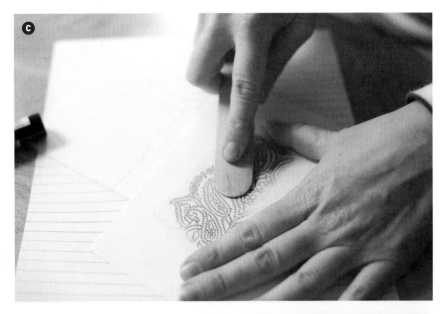

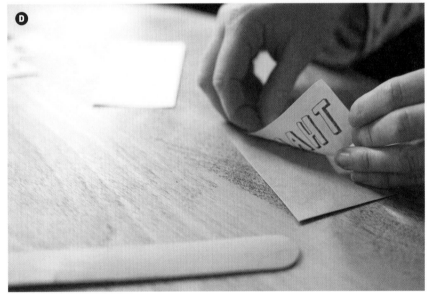

until the image is transferred. Do the same for the envelope. I like the continuation of design from envelope to card, but consider using your own drawings, sketches, or lettering to create a suite of impromptu enclosures. (See D.)

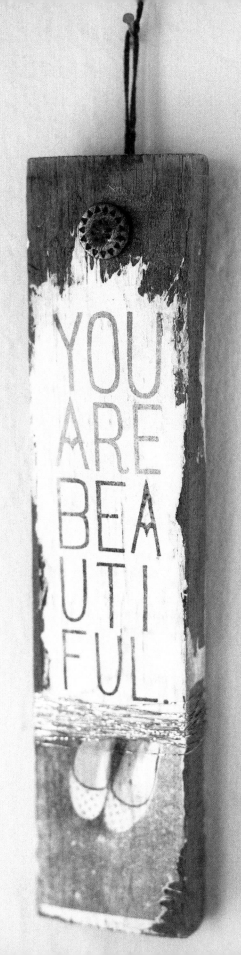

Upcycled Sign

Lettering by Sam O'Leary

Make a vintage-inspired sign using rustic recycled wood scrap. You may have a phrase or quotation you find inspirational. Turn that thought into an object you can place on a shelf or hang on the wall for an everyday reminder.

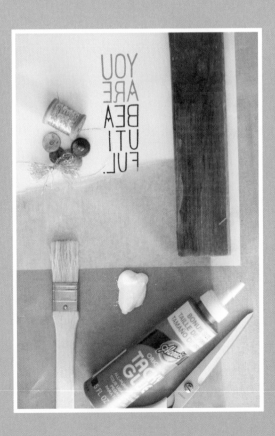

✂ MATERIALS

- ✔ Method: Acrylic Paint Transfer (see page 28)
- ✔ paintbrush
- ✔ white acrylic paint
- ✔ distressed wooden scrap
- ✔ black-and-white photocopy of text (reversed)
- ✔ damp sponge and water
- ✔ thread
- ✔ tacky glue
- ✔ button
- ✔ other ephemera

💬 CONSIDERATIONS

This technique is a fun way to make signage for any event. Use in a wedding for a Mr. & Mrs. sign to hang on the back of a bride and groom's chair! This would also be a great housewarming gift.

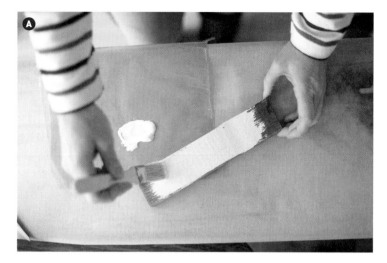

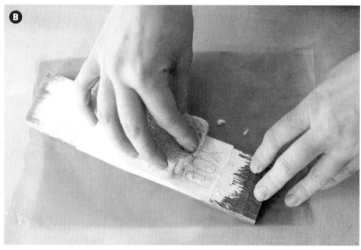

1 Brush an even coat of paint on the wooden surface. Try using a dry brush method: pounce with a cheap bristled brush to get feathered soft edges of paint. (See A.)

2 While the paint is wet, place the photocopy face down and burnish lightly with your fingers. I placed an image of shoes below the lettering, leaving a small gap between the two, so I can come back in and add thread later. Allow to dry completely!

3 Using a damp sponge, gently remove the paper backing with circular motions. Continue adding water and removing paper pills gently until the entire image is revealed. (See B.)

4 This is a great opportunity to make this an object instead of just words on wood. Wrap thread, such as a metallic, around the wood many times until you build up a band of threads. Secure with a dab of glue. (See C.)

5 Add a final element to finish. I added a vintage metal button to visually ground the image and add another texture. Secure the button in place with a dab of heavy crafting glue. You could also hammer in a small object like an old nail, a milagro, or another finding. (See D.)

TIP

If you're having difficulty getting a clean image, try using a weathered piece of wood that is fairly smooth. At worst, you can paint over a failed image and try the process again.

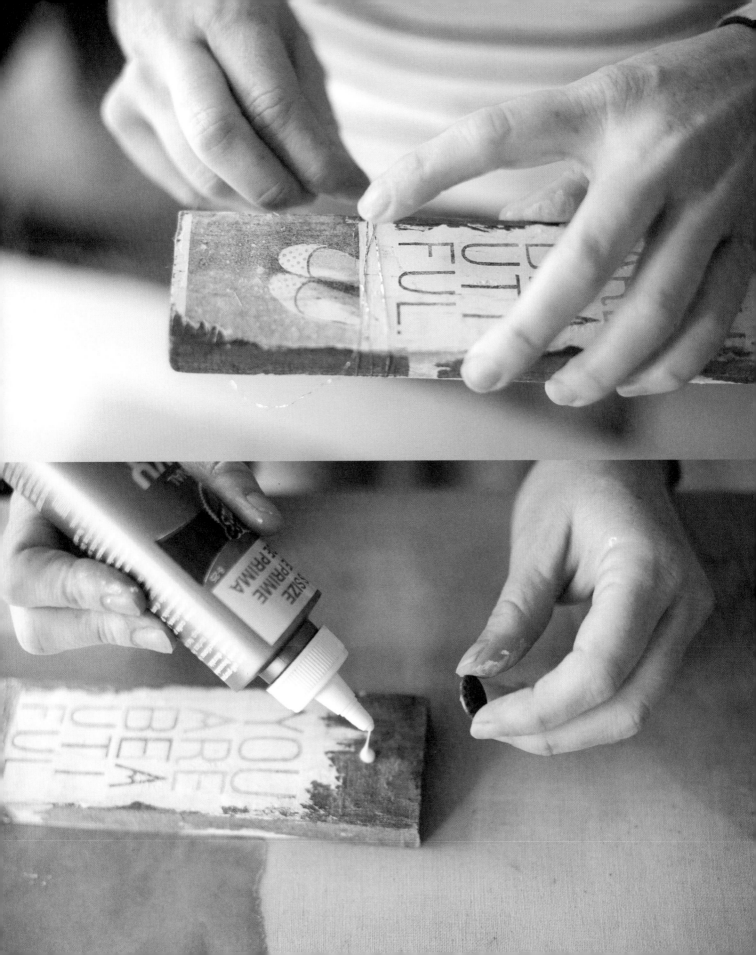

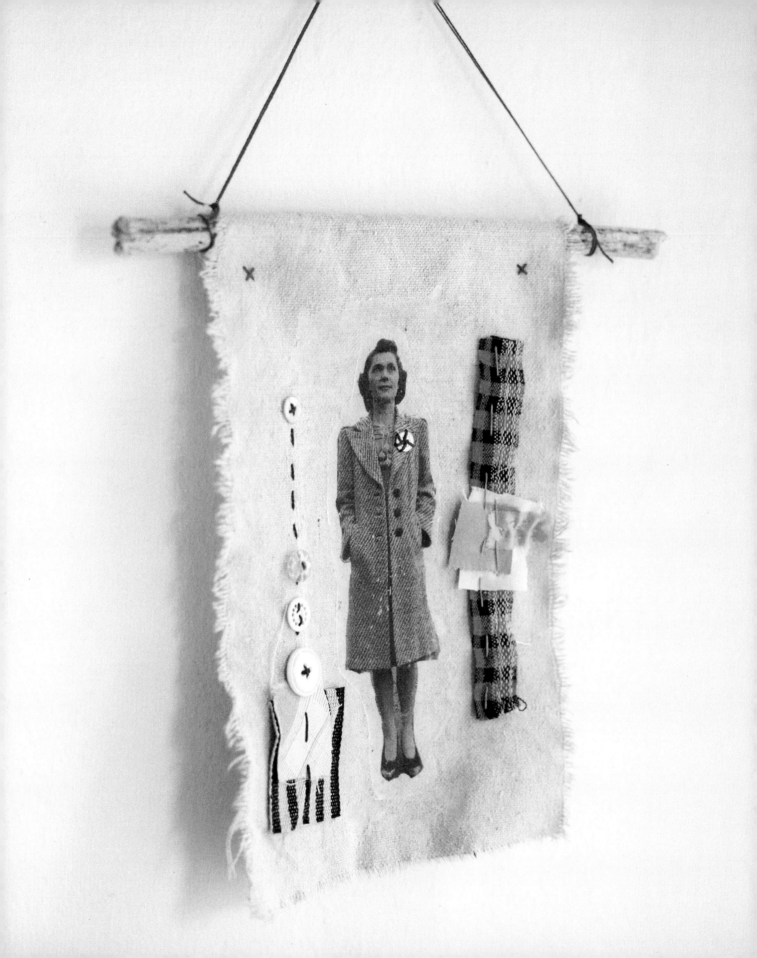

Mixed-Media Wall Hanging

Both my grandmas were handy with a needle and thread. My grandma Louise (pictured on page 89) was a huge part of my childhood and made me many, many outfits. When she died this year, her sewing kit was one of the things I was most happy to have, along with my memories of her sitting at her sewing machine and me on the floor, organizing her threads and notions alongside her. I never knew my grandma Virginia (pictured on page 86), but I inherited her green tin of buttons and a half-finished needlepoint. Along with these items, I grew up with albums filled with beautiful images of them both.

✂ MATERIALS

- Method: Gel Skin Medium Transfer (see page 26)
- piece of canvas or heavy cloth
- glue brush
- gel medium
- black-and-white or color photocopy (reversed)
- sponge and water
- scrap fabric, buttons, and ephemera
- needle
- heavy thread
- driftwood or vintage frame

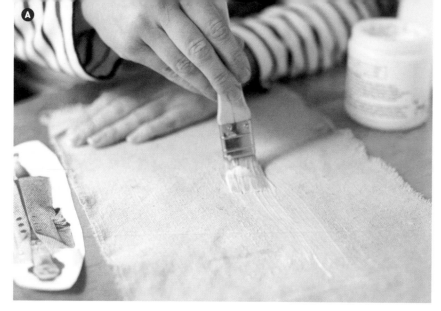

1 Cut or tear your canvas down to a workable size. I love using canvas drop cloth from the hardware store. In small quantities, it can look like a heavy gray linen, and it's so much fun to tear!

2 Brush on an even coat of gel medium (or acrylic paint) onto the center of the fabric. If you plan to hang this from a branch, you'll want to leave 2 to 3 inches (5 to 7.6 cm) at the top to allow for hanging. (See A.)

3 Place the photocopy face down into the wet medium and burnish lightly with your fingers. Allow to dry completely!

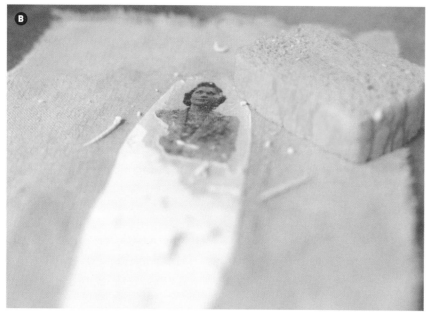

4 Once dry, gently remove the paper pulp with a damp sponge, using circular motions. Add water and remove paper pills as necessary until the image is revealed. (See B.)

5 Compose fabric scraps around the image. Layer long strips of bold plaids with small stacks of squares in neutrals and a small pop of neon to bring it to life! Stitch in place. (See C.)

6 Layer in buttons with a simple running stitch using a deep red thread. Add stitches as embellishments, too. Consider using parallel lines of running stitch or little French knots to build up texture. (Check out Rebecca Ringquist's work at www.rebeccaringquist.com for a burst of embroidery inspiration if you're feeling shy about embroidery.) (See D.)

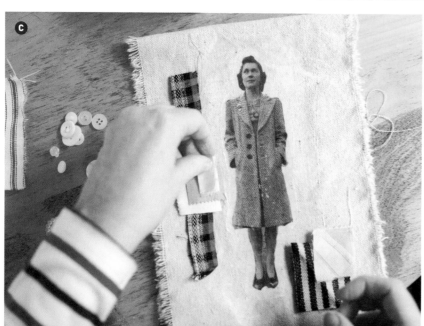

7 You can easily place this piece in a vintage frame, but I love allowing its sculptural quality to show through by hanging it on a branch or piece of driftwood. Fold the top few inches over a branch and secure in the left and right corner with a simple X stitch. Hang with a length of thread.

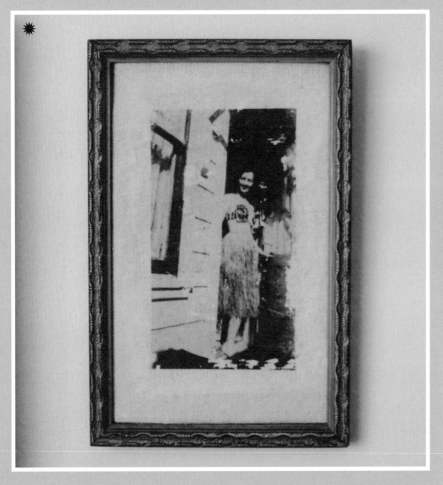

✳VARIATION

.................................

Gel medium transfer on drop cloth without embellishments, in vintage frame.

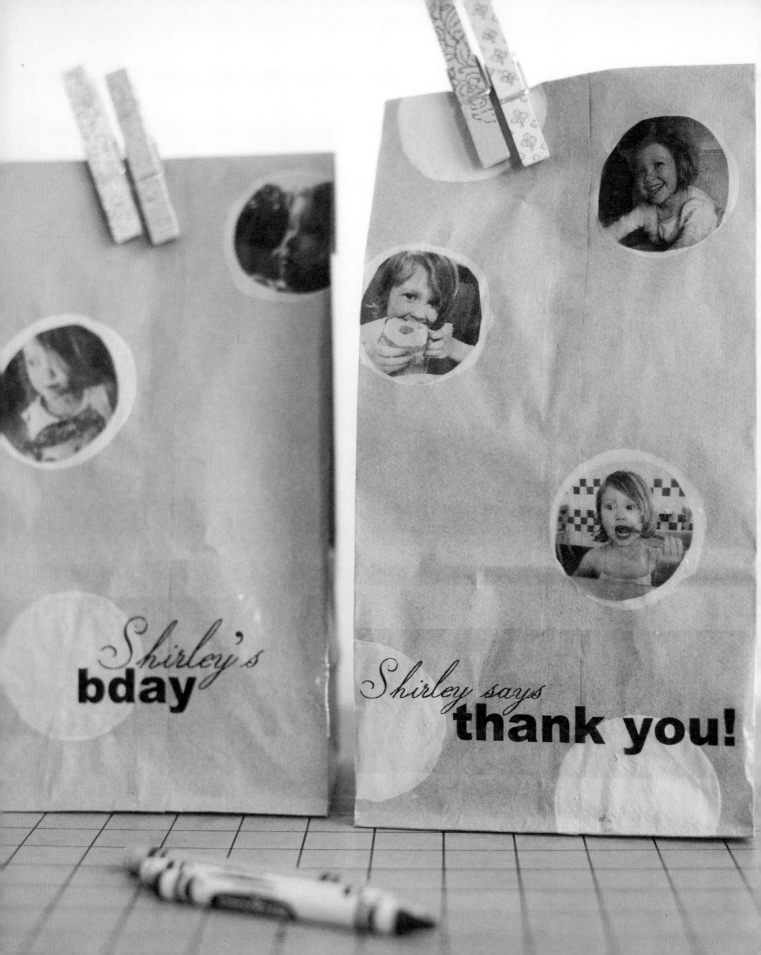

Party Pack

I must have not outgrown my childhood because there is something so thrilling in making things for children. A friend's amazing photos of her daughter Shirley inspired me to create these fun little party packs complete with pictures of Shirley as thank-you takeaways.

✂ MATERIALS

- ✔ Methods: Packing Tape Transfer (see page 20) and Blender Pen Transfer (see page 22)
- ✔ acrylic craft paint in two or more colors
- ✔ waxed paper for a palette
- ✔ foam circle stamp or circle potato stamp
- ✔ kraft paper lunch bags
- ✔ scissors
- ✔ small packing tape transfers of the birthday child
- ✔ paintbrush
- ✔ clothespins (optional)
- ✔ blender pen
- ✔ black-and-white photocopy of a small pattern
- ✔ glue stick

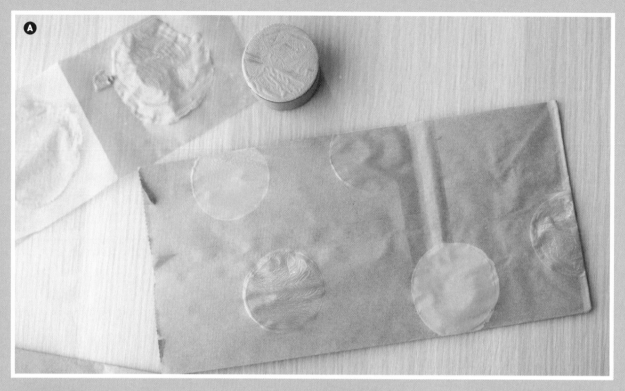

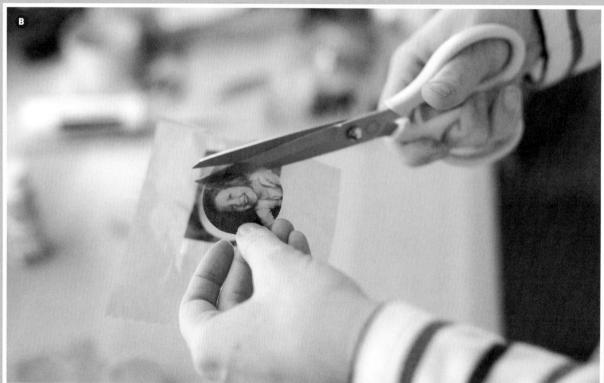

1 Squirt a small puddle of acrylic paint onto your waxed paper and gently dab the foam or potato stamp into the paint. Place dots over the surface of the lunch bag in a random order. I like to do all the bags at once, placing all the pink dots first and then washing my stamp and stamping all the aqua dots next. Be sure to print off the edge of the bag, too, for a dynamic design. (See A.)

2 Cut the packing tape transfers so they are slightly smaller than the circle stamp. This is really free-form; imperfect circles will create an off-register look. You could also make your transfers larger than the painted dots for a different effect. (See B.)

3 Once the painted dots are completely dry, place the transfers over each dot. You could select to do only pink dots, or a few on each bag, or whatever you like. (See C.)

4 To up the cute factor, add a painted clothespin to seal the bag. Paint the clothespins in matching acrylic paint and allow to dry. (See D.)

5 Create a blender pen transfer using the photocopy of a small pattern (see page 22). You could also use a phrase, the date, or the words "Thank You." Make sure your photocopy is reversed if transferring text.

6 I also added packing tape transfers at the bottom of the bag using text I generated on the computer. This is an extra, but easy, addition to the perfect goodie bag.

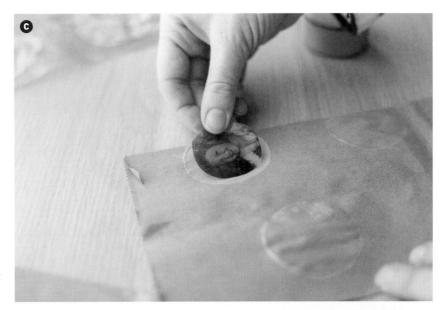

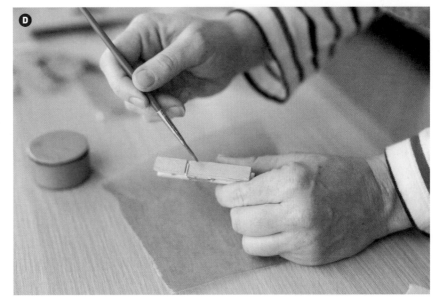

TIP

Use a glue stick if the transfers aren't sticky enough on their own.

Typewriter Tape

This technique is perhaps my one claim to genius. I was playing with tape one night, wishing I could get text onto a piece of masking tape, and my sleep-deprived brain came up with this technique. If you don't have a tape addiction by now, this method will swiftly hook you.

1 Tear a piece of waxed paper (not parchment) to about 8 1/2 inches (21.5 cm) wide; the length can be 4 inches (10.2 cm) or longer.

2 Place the waxed paper over a sheet of lined paper and square up. Place pieces of masking tape on the waxed paper, aligning the bottom edge of the tape to a line on the lined paper below. Continue adding strips of tape, skipping two lines between each. (See A.)

3 Run the waxed paper through the typewriter with the tape facing you and type away! Add artist's tape for a bit of color.

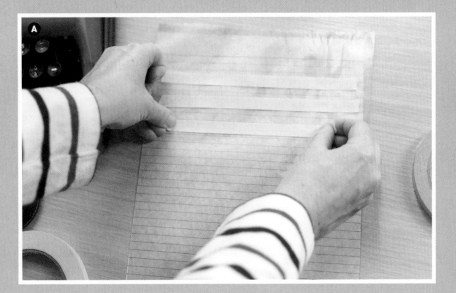

A

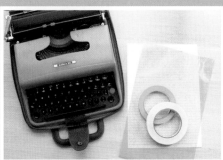

✂ MATERIALS

· ·

- ✔ Method: Typewriter Tape Transfer
- ✔ waxed paper
- ✔ sheet of lined paper
- ✔ masking tape in 1/2" (1.3 cm) width
- ✔ typewriter
- ✔ artist's tape in desired width (optional)

🖋 CONSIDERATIONS

· ·

I love using these bits of tape on cards and in sketchbooks. For all you crafters out there, this is a great way to add some pretty nifty type to your packaging! Ask around to see whether a friend or family member has a typewriter sitting unused in the back of a closet. If you can't find a typewriter to borrow, you can purchase them online or at estate sales, garage sales, or thrift stores.

Collage made with typewriter tape and packing tape

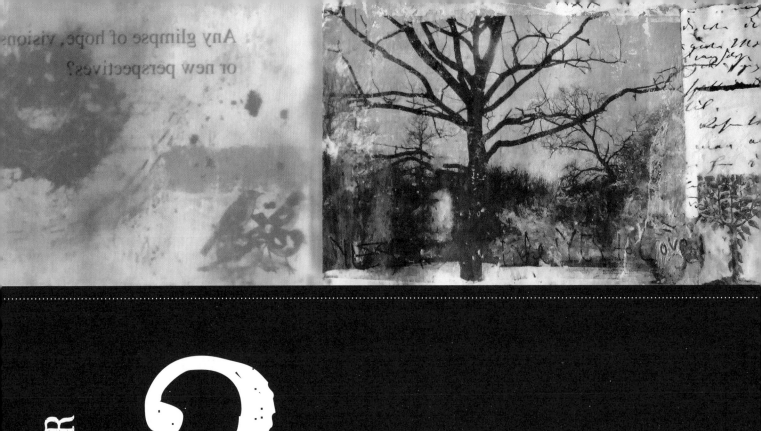

Any glimpse of hope, visions, or new perspectives?

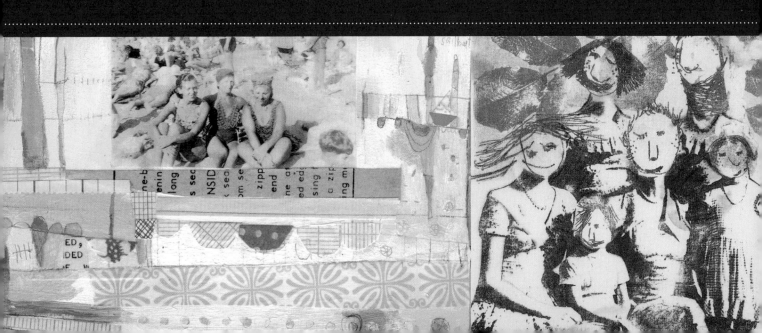

GALLERY:
Exploring Transfers in Mixed-Media Artworks

Image transfers are a versatile medium, and I am reminded of their limitless potential when I see how other artists use them. Each of the artists featured in the gallery use transfers in unexpected and remarkable ways. Their interpretation of the medium reminds me of the great beauty that can be achieved with these simple methods.

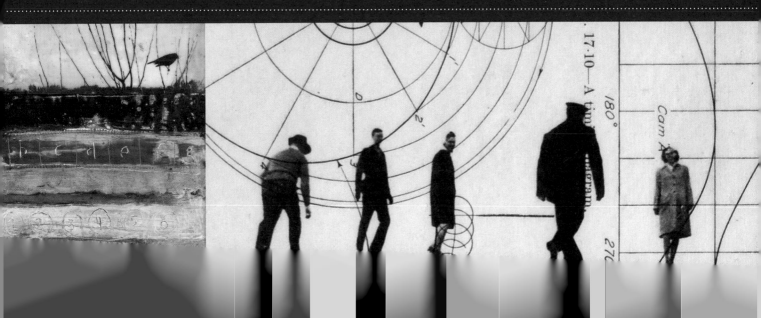

Bridgette Guerzon Mills is a mixed-media artist whose work incorporates a variety of materials, including photography, oils, acrylics, and encaustic. Her artwork and journals have been published in magazines and books, and her work has been collected and exhibited in the United States and internationally. She currently resides in Chicago.

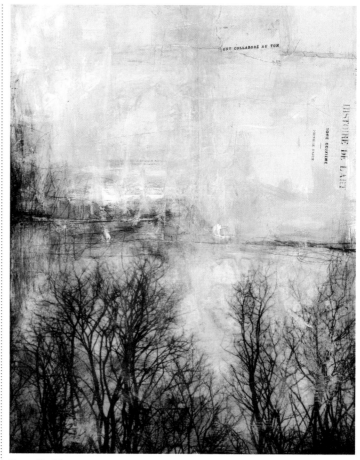

Upon the Sky
encaustic mixed media

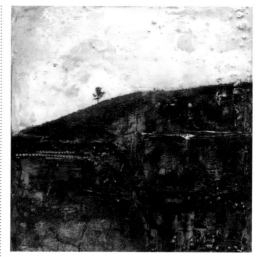

Spaces Between
encaustic mixed media

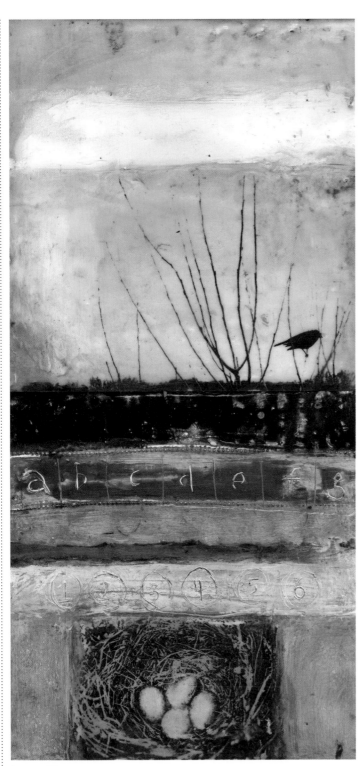

Lesson Plans
encaustic mixed media

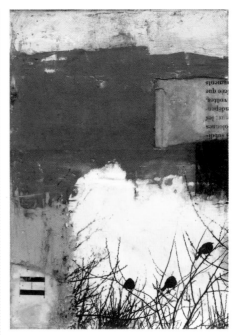

Hidden Selves
encaustic mixed media

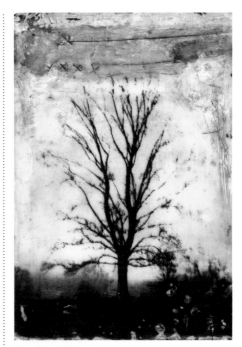

Outside of Time
encaustic mixed media

Kristine Fornes was born in Longyearbyen, Norway, in 1971. She lives in an artists' colony in Oslo, Norway. Gallery owner Nina Svane-Mikkelsen says, "Her meticulously embroidered stitches and transferred drawings and photos on old, worn, and washed-out textiles comment in various ways on times gone by, times today, and times yet to come. Her pieces are, quite simply, powerful examples of a folklore still alive and well. Fornes's pieces feel like 'tellings,' like the new old stories of the rural culture. They are like conversations between the past and the present, between young and old, recorded by a cartoonist with a needle and thread."

Photos by Jørn G. Lang

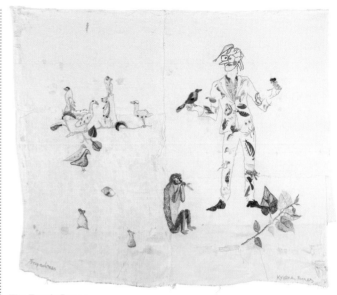

The Tropic Dress
image transfer, hand embroidery, and sewing on linen and cotton

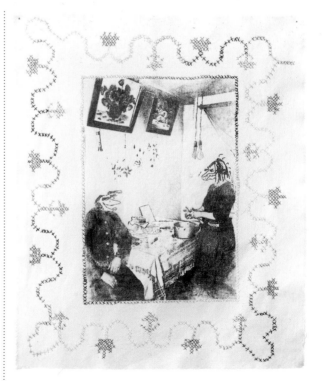

Second Breakfast
image transfer and hand embroidery on canvas

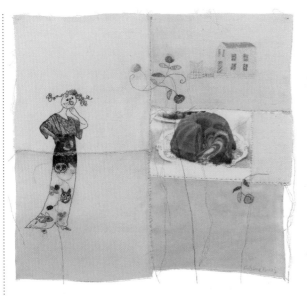

Dozy Rozy—Never Married
image transfer, drawing, and hand embroidery on silk

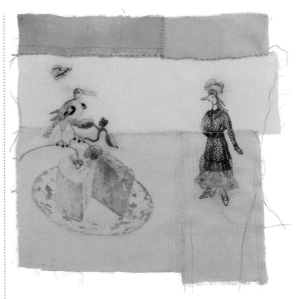

Eliza in Her Crinoline
print, drawing, and hand embroidery on silk

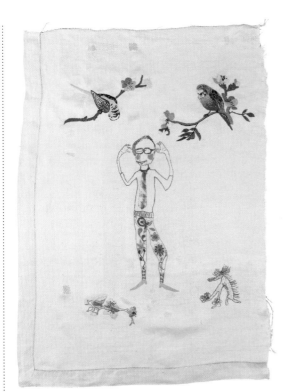

Spring in Sight
image transfer, hand embroidery, and sewing on linen and cotton

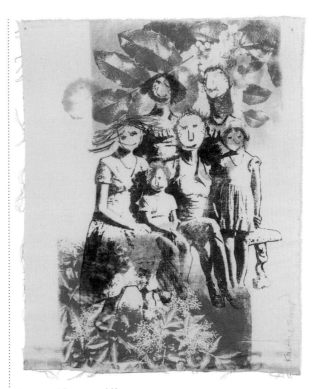

Love and Common Life
print on canvas

Alisa Nordholt-Dean is a self-taught mixed-media artist with a passion for all things vintage. Her love of vintage photographs led her to begin incorporating image transfers into her mixed-media work in 2008. She teaches workshops locally, and her work has been published in *Somerset Studio* magazine. A lifelong Hoosier, Alisa currently resides in Greenwood, Indiana, with her husband and two daughters.

Photos by the artist

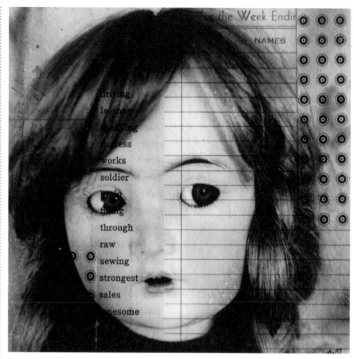

Baby Doll #3
mixed media on canvas

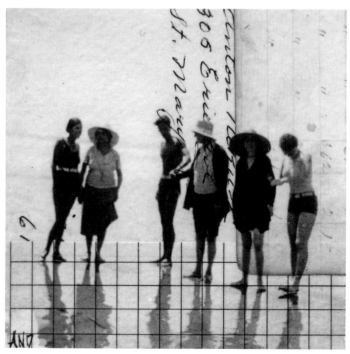

The Beach #2
mixed media on canvas

Fig. 17·11—Layout of plate cam.

Fig. 17·10—A tim...

90°

180°

270°

Cam A...

Walkers
mixed media on canvas

Cathy Cullis is a mixed-media artist and poet whose work is inspired by a love of art history and folk art. Influences include the "outsider artist" Madge Gill, who created detailed, patterned ink drawings. Just as Madge Gill worked intuitively, Cathy uses her sewing machine as a drawing tool, to explore an everlasting world of organic movement, figures, and gazing faces. In recent years, Cathy's writing has become more experimental as she explores the playfulness of language and meaning, art making and history, nostalgia, and women's lives.

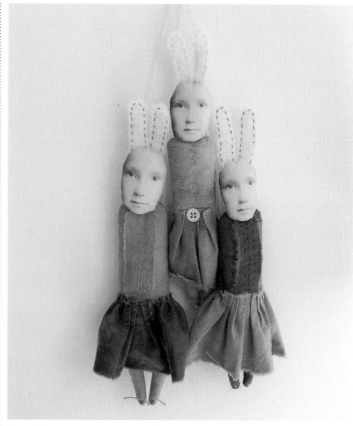

Yesterdays
mixed media

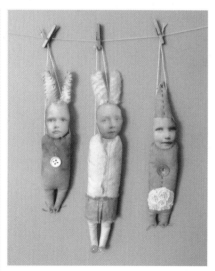

Yesterdays
mixed media

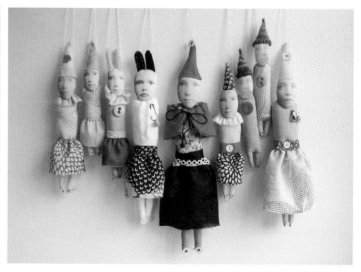

Yesterdays
mixed media

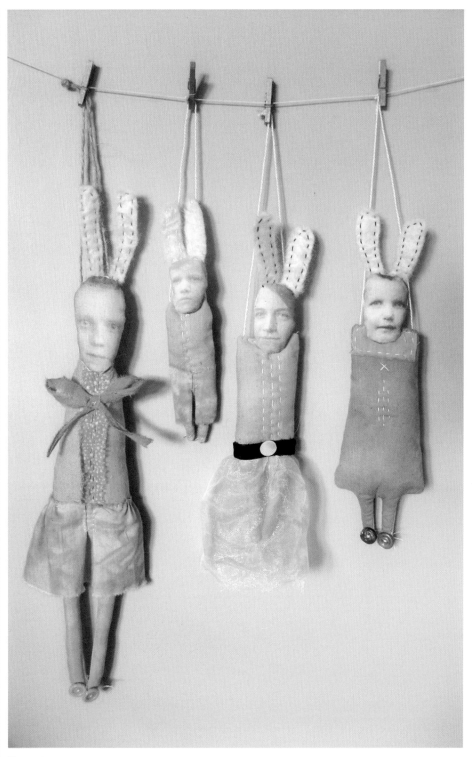

Yesterdays
mixed media

Dominique Fortin Always balancing between realism and abstraction, Dominique's recent work invites us to take part in a theatrical scene where horses, birds, dancers, and various characters act in a carnivalesque ballet that is at once amusing and intriguing. Dominique's creative process involves a great variety of techniques: collagraphy, scratching, projection, running paint, gilding, stenciling, and image transferring, all enhanced by fabrics and other materials assembled in pictorial layers. Each painting offers the viewer multiple interpretations and as one gets closer, a variety of textures and symbols that were once invisible become revealed.

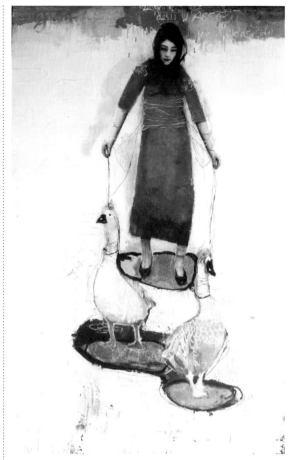

Vers la vie en dedans tout autour
mixed media

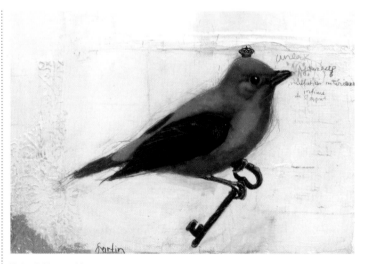

Unlock Yourself
mixed media

Photos by the artist

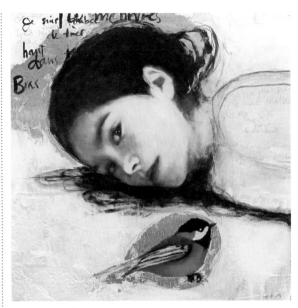

Tomber de très haut dans tes bras
mixed media

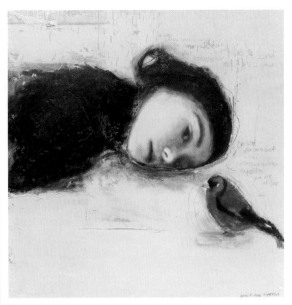

Forcément épris, mon amour
mixed media

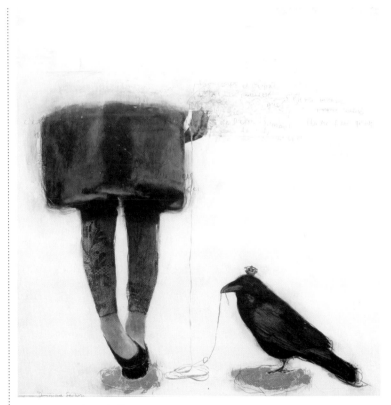

Corps et esprit, ou le lien
mixed media

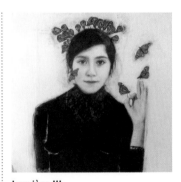

Lumière III
mixed media

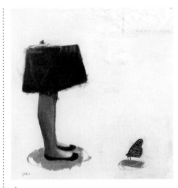

À ta rencontre
mixed media

Hanne Matthiesen is a Danish mixed-media artist, teacher, facilitator, and curator who works mostly with collages, unique artists' books, and various kinds of installations and art projects. Her works are usually based on "simple" materials such as recycled paper, vintage fabrics, found objects, and natural materials that are transformed into her unmistakable, beautifully minimalist, and deliberate style. Universal, existential, and metaphysical questions are the major themes in Hanne Matthiesen's art. Her interests are in life, death, and resurrection—or you could say the cycle of life—combined with a sobering, straightforward, and down-to-earth documentation of the "moment," NOW and HERE, of everyday subjects, the daily miracle of life, and the overlaps and cracks between the mundane and the sacral worlds.

Photos by the artist

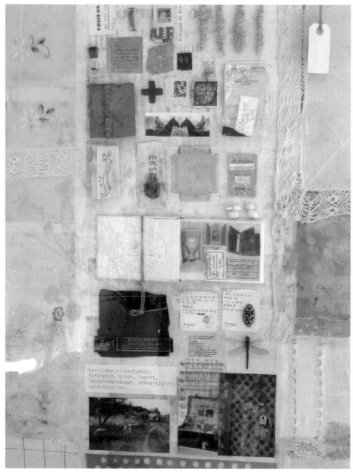

Opslagstavle
mixed media

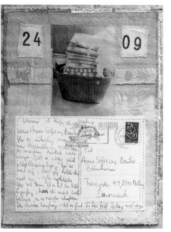

Collage
mixed media

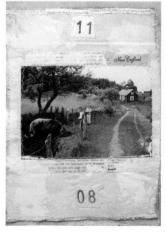

Collage
mixed media

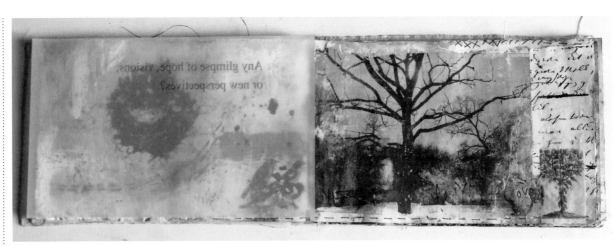

From Book of Love, collaboration with Bridgette Guerzon Mills
mixed media

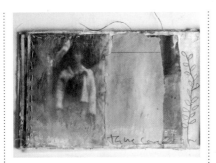

From Book of Love, collaboration with Bridgette Guerzon Mills
mixed media

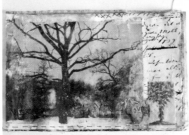

From Book of Love, collaboration with Bridgette Guerzon Mills
mixed media

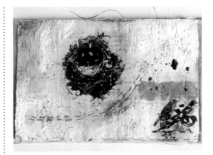

From Book of Love, collaboration with Bridgette Guerzon Mills
mixed media

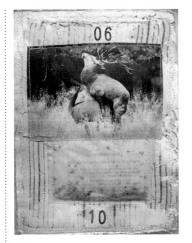

Collage
mixed media

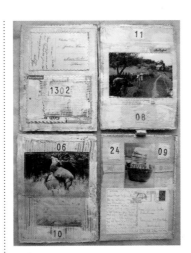

Collage
mixed media

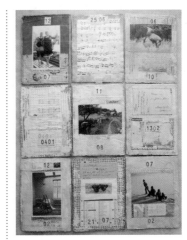

Collage
mixed media

Jody Alexander is an artist, a bookbinder, a papermaker, a librarian, and a teacher who lives and works in Santa Cruz, California. She makes paper in the Eastern style, and uses her papers to bind books with exposed sewing on the spine in a number of historical and modern binding styles. She combines these books with found objects, wooden boxes and drawers, metal, bones, and similar objects to create sculptural works. Her pieces celebrate collecting, storytelling, and odd characters. She also likes to rescue books in distress and give them new life as rebound books, scrolls, and sculptural pieces.

Photos by R. R. Jones

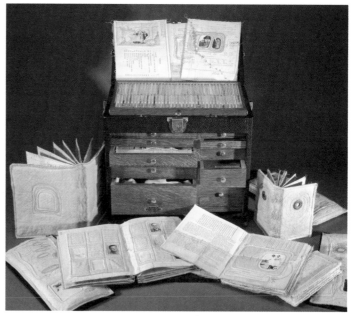

The Odd Volumes of Ruby B.
fabric, discarded book pages, photographs, and thread

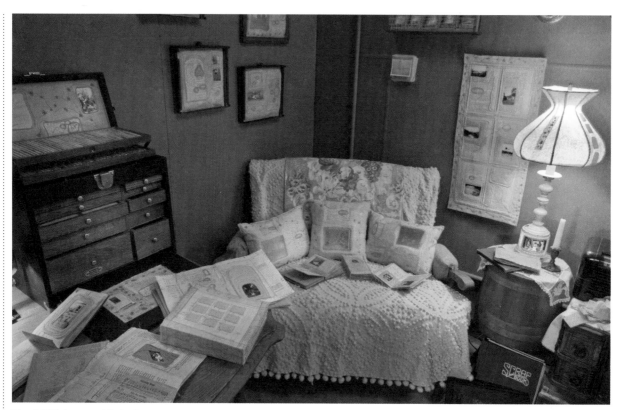

The Odd Volumes of Ruby B.
fabric, discarded book pages, photographs, and thread

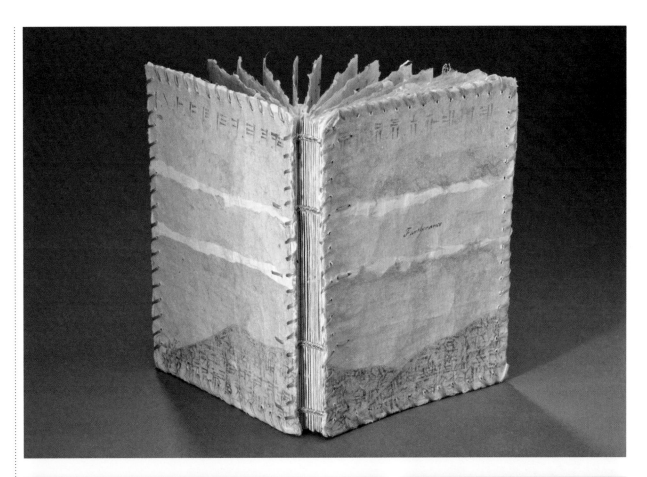

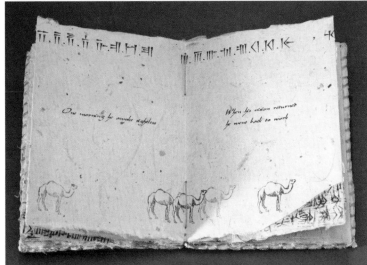

Furtherance
handmade kozo/gampi paper, handmade flax paper on the covers, black-and-white photocopy transfers (using eucalyptus oil), black pencil, artificial sinew thread binding, and Ethiopian Coptic binding

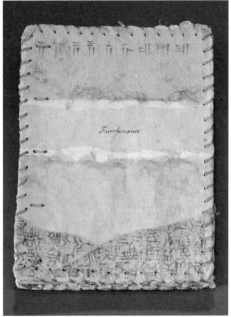

Joan Deichert's love of old homes has always played a part in her mixed-media collages. Her favorite daily pastime is to discover hidden rundown houses and imagine what they might look like inside, or what she hopes they are like inside.

In the image transfers she creates, she uses photographs, drawings, blueprints, and words to convey the history of period architecture that she never wants to forget. She uses acrylic paint to transfer her images and words and combines vintage book pages, found objects, and stitched textures and shapes to tell a story about lives that have already taken place.

She starts out with one picture or found object and then all the pieces seem to fall into place to help her tell a story that she associates with the piece she has focused on. The image transfers make a wonderful subtle background or addition of texture to her pieces. It's always curious how the transfers turn out and how the clarity of the transfer shapes the direction of the piece. Sometimes, what she first considers to be a "mistake" with the transfer will evolve into a piece quite unexpected and better than she could have ever imagined. It's just learning when to go with the direction the piece has created on its own.

Photos by Chelsea Almater

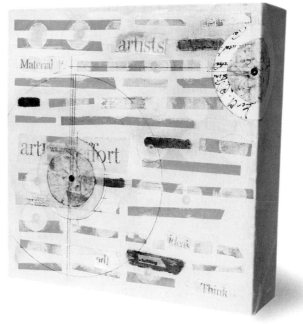

Art Effort
painted canvas, copper leaf, image transfers, kraft paper, mixed media

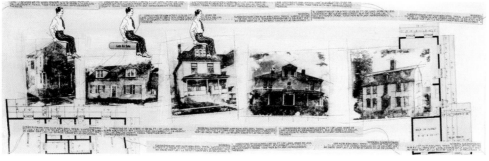

Architects and Their Dreams
image transfers of houses from historical architecture book, floor plans from same book, multiple reproductions of sitting man, sewn newspaper clippings

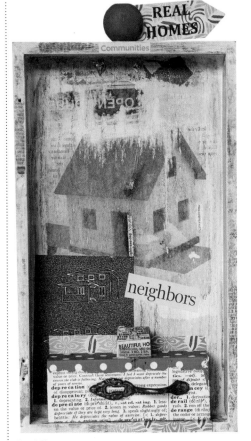

Real Homes
transfer from newspaper article, copper leaf, wooden box lid covered with image transfers, blueprint from book, Monopoly house, key escutcheon

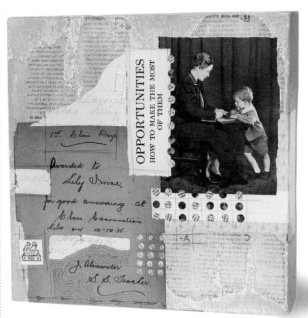

Opportunities
pages from vintage school book, transfer from book pages, handwritten note, mixed media

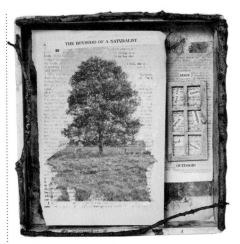

Boyhood of a Naturalist
painted wooden box, twigs, image transfer, mixed media

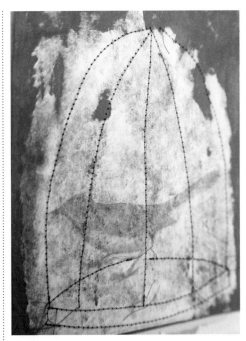

To Mary (detail)
vintage book cover, kraft bag, image transfers, mixed media

Sarah Ahearn Bellemare is a mixed-media painter who lives in Northampton, Massachusetts, with her ecologist husband and chubby-cheeked, adorable baby girl. She has been an artist for as long as she can remember and feels extremely fortunate that her passion and career have merged and that being an artist is now her job. Sarah's mixed-media paintings are layered with found images, fragments of text from old books, and pieces of vintage maps. These ephemera become the fabric and focus of her whimsical paintings, many of which are inspired by her childhood memories of time spent by the seashore on Cape Cod. Her first book was *Painted Pages: Fueling Creativity with Sketchbooks and Mixed Media* (Quarry Books, May 2011).

Photos by the artist

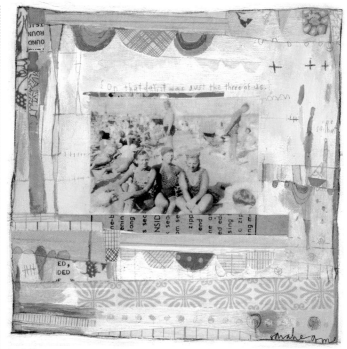

Just Us
acrylic, mixed media, collage, and image transfer

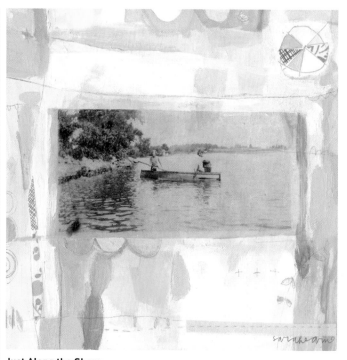

Just Along the Shore
acrylic, mixed media, collage, and image transfer

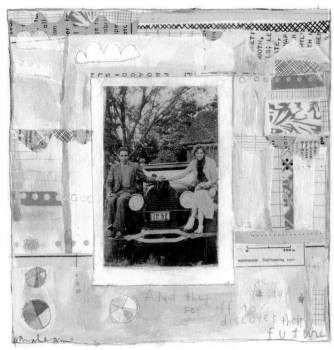

Off on Their Adventure
acrylic, mixed media, collage, and image transfer

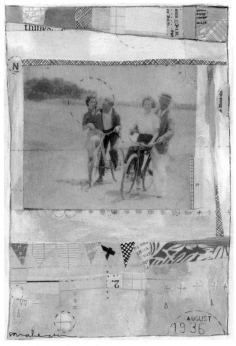

Sunshine Followed
acrylic, mixed media, collage, and image transfer

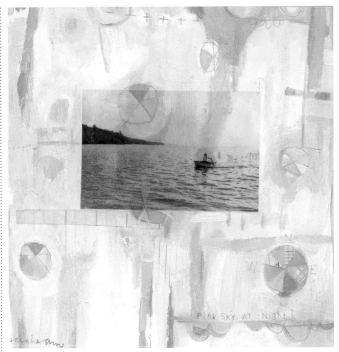

Pink Sky
acrylic, mixed media, collage, and image transfer

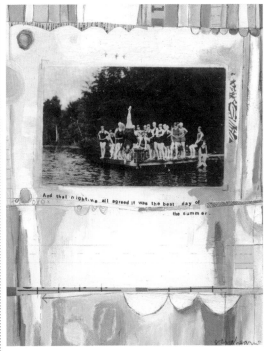

Girls on the Dock
acrylic, mixed media, collage, and image transfer

Matthieu Brajot is a designer currently living in San Francisco. He loves kitties (especially the fluffy ones), pickles (the French kind), music (on repeat), zombies (fast and slow), patterned socks (usually made for girls), movies (generally the B kind), and vintage type, among many other things.

Photos by the artist

Zombie ABC packaging
packing tape transfers

Zombie Knob packaging for Ghostnest.com
packing tape transfers

Zombie ABC poster
poster showing the original graphic

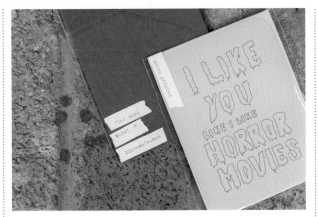

Typewriter tape packaging
typewriter tape

Packing tape decal on laptop
packing tape decal

Dorothy Simpson Krause is a painter, collage artist, and printmaker who incorporates digital mixed media into her art. Her work is exhibited regularly in galleries and museums and featured in numerous current periodicals and books. She is the author of *Book + Art: Handcrafting Artists' Books* (North Light, 2009) and coauthor of *Digital Art Studio: Techniques for Combining Inkjet Printing with Traditional Art Materials* (Watson-Guptil, 2004).

Photos by the artist

Alleyway
emulsion transfer on Stone-Paper using Digital Art Studio Seminars transfer film and SuperSauce (edition of six)

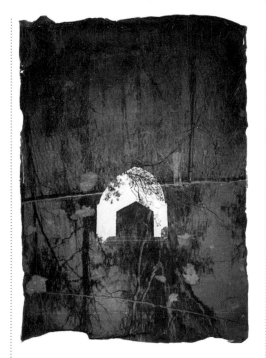

Reflection
emulsion transfer on Stone-Paper using Digital Art Studio Seminars transfer film and SuperSauce (edition of six)

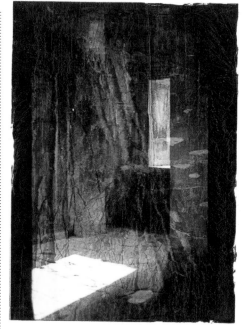

Golden
emulsion transfer on Stone-Paper using Digital Art Studio Seminars transfer film and SuperSauce (edition of six)

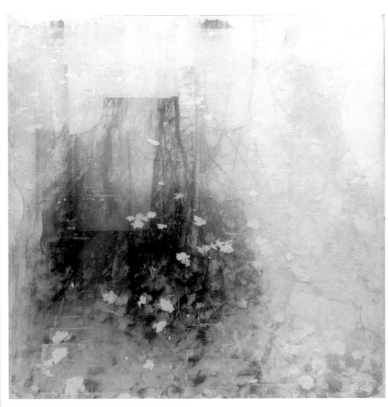

Holy and Enchanted
transfer to fresco using Digital Art Studio Seminars transfer film and SuperSauce

Savage Place
transfer to canvas using Digital Art Studio Seminars transfer film and SuperSauce

Sinuous Rills
transfer to aluminum using Digital Art Studio Seminars transfer film and SuperSauce

Lisa Kokin In her never-ending quest to find different ways to eviscerate books, Lisa Kokin stumbled upon book collage. First, she finds a discarded book that interests her, either for some element of text, image, or marginalia or for the look of the book itself. Sometimes, she removes some of the pages and glues and/or sews the book open to a particular spread of interest. Other times, she removes all the pages and uses the inside covers as the collage surface. She builds upon what initially interests her by layering images and text from the same or other books, found photos, and other small objects, using a variety of collage and transfer techniques. Lisa's work has been exhibited and collected extensively in the United States and abroad. She is represented by Seager Gray Gallery in Mill Valley, California; Gail Severn Gallery in Sun Valley, Idaho; Tayloe Piggott Gallery in Jackson, Wyoming; and Craighead Green Gallery in Dallas, Texas.

Photos by Lia Roozendaal / Jagwire Designs

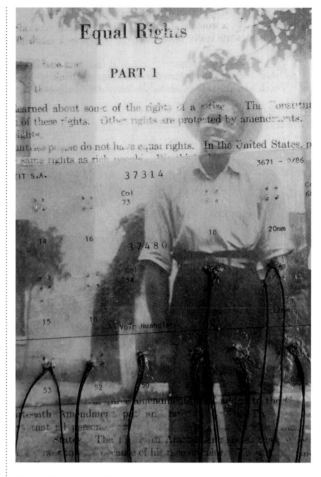

Equal Rights (detail)
mixed-media book collage with gel medium transfer

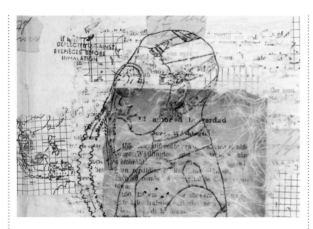

El Amor a la Verdad (detail)
mixed-media book collage with blender pen transfer

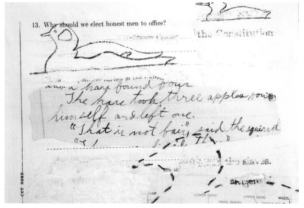

Parable (detail)
mixed media

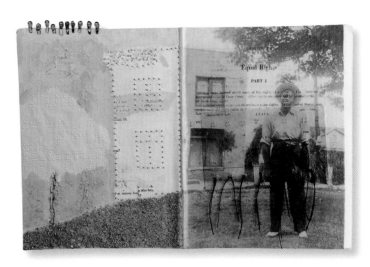

Equal Rights
mixed-media book collage with gel medium transfer

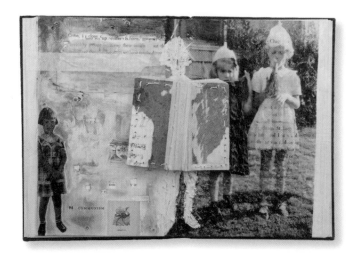

Our Kind of Freedom
mixed-media book collage with gel medium transfer

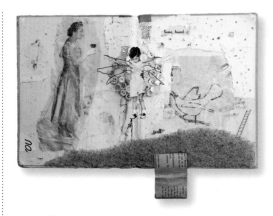

Some, Found
mixed-media book collage with blender pen transfer

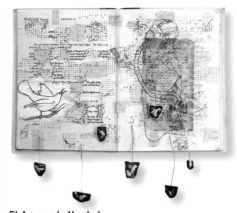

El Amor a la Verdad
mixed-media book collage with blender pen transfer

Templates

Most of the provided images can be used in multiple projects. Play around with changing the size and copying in both color and black and white.

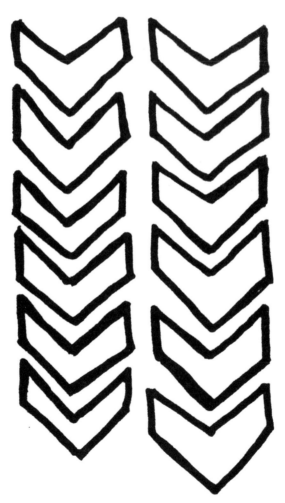

Packing Tape Postcard (see page 33)
Fabulous Gift Wrap (see page 67)

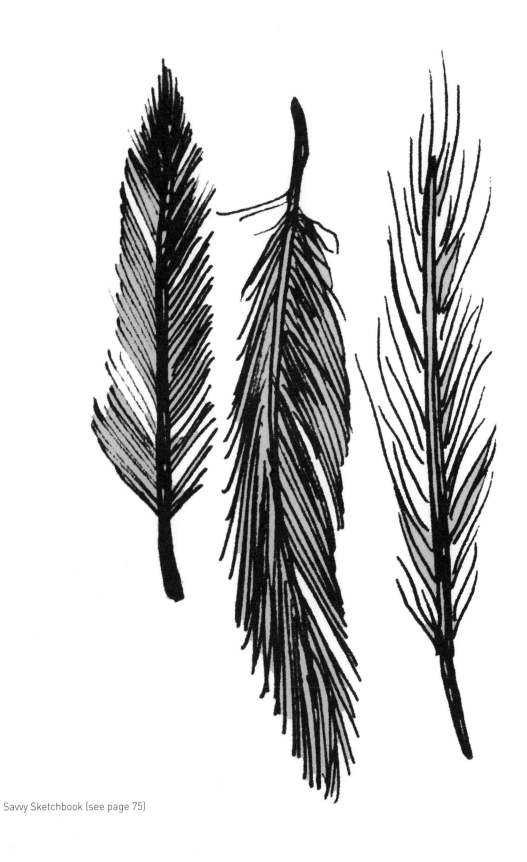

Savvy Sketchbook (see page 75)

Stationery Suite (see page 79)

Stationery Suite (see page 79)

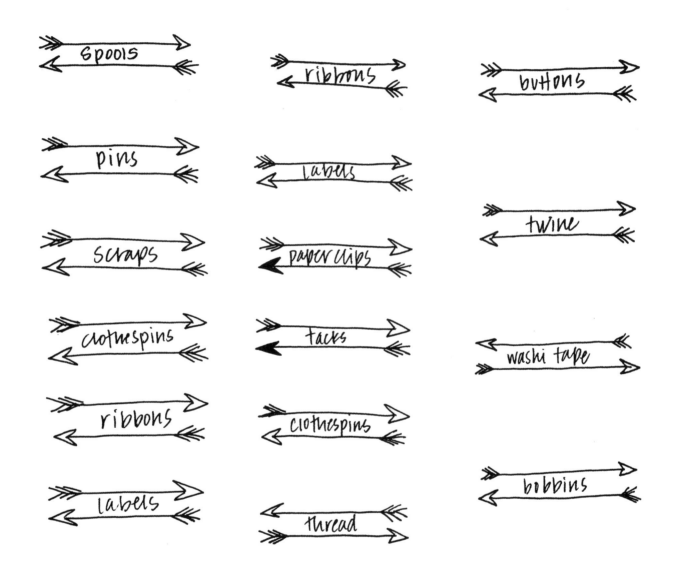

Craft Jar Labels (see page 62)

Fabulous Gift Wrap (see page 67)

Fauxlaroids (see page 36)
Bohemian Fabric Bunting
(see page 59)

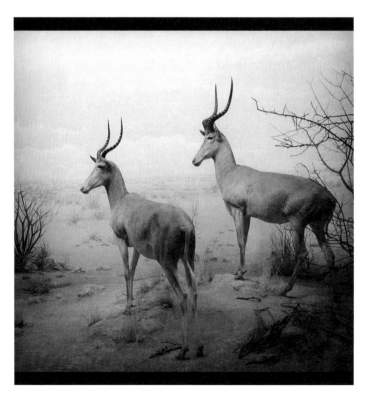

Fauxlaroids (see page 36)

Fauxlaroids (see page 36)

Bohemian Fabric Bunting
(see page 59)

Fauxlaroids (see page 36)
Bohemian Fabric Bunting (see page 59)

Fauxlaroids (see page 36)

Fauxlaroids (see page 36)
Bohemian Fabric Bunting
(see page 59)

Fauxlaroids (see page 36)

Fauxlaroids (see page 36)

Fauxlaroids (see page 36)

Microscope Slide
Necklace (see page 49)

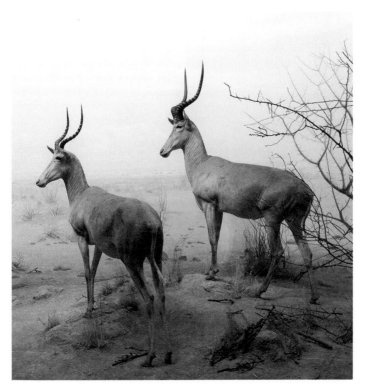

Packing Tape Postcard
(see page 33)

Lettering by Matthieu Brajot
Savvy Sketchbook (see page 75)

Lettering by Matthieu Brajot
Fabulous Gift Wrap (see page 67)

THANK YOU

Lettering by Matthieu Brajot
Fabulous Gift Wrap (see page 67)

THANK YOU

Lettering by Matthieu Brajot
Stationery Suite (see page 79)

Clip Art by Dover Publications
Savvy Sketchbook (for the pencil) (see page 75)

Clip Art by Crap Hound
Layered Love Note (see page 64)

Resource Guide

Arch Supplies
www.archsupplies.com
Arch has the Chartpak blender pen, gel medium, and lots of good washi tape and artist's tape in addition to a million and one awesome art supplies and art-inspired gifts.

Creativbug.com
www.creativebug.com
This is an amazing resource of online video tutorials, techniques, and inspiration. You'll find all kinds of incredible artists teaching their craft. You can check out my image transfers class and other workshops here.

Dick Blick Art Materials
www.dickblick.com
Art and transfer supplies.

Dover Publications
store.doverpublications.com
For clip art and books.

Issue Magazine Shop
www.issuesshop.com
This is great for all printed matter, but especially great because they carry *Crap Hound* magazine.

Jo-Ann Fabrics and Crafts
www.joann.com
Art, craft, and transfer supplies.

Michaels
www.michaels.com
Art, craft, and transfer supplies, wood plaques, papers.

Press: Works on Paper
www.pressworksonpaper.com
I love this little shop for its collection of vintage office supplies, rare books, and new and interesting office products. You can get metallic pencils here, great notebooks, and vintage typewriters, too!

San Francisco Center for the Book, aka SFCB
www.sfcb.org
Come take a class with me in person or just check out the bindery, letterpress studio, and gallery!

Uline
www.uline.com
For packing tape larger than 2 inches (5 cm) wide (4 inch [10 cm] tape item #S-216, 6 inch [15.2 cm] tape item #S-616).

Contributing Artists

Jody Alexander
www.jalexbooks.com

Sarah Ahearn Bellemare
www.sarahearn.com

Matthieu Brajot
www.llamacafe.com

Cathy Cullis
cathycullis.blogspot.co.uk

Joan Deichert
www.etsy.com/shop/gatheredtogether

Kristine Fornes
www.kristinefornes.no

Dominique Fortin
www.lafeedargent.com

Lisa Kokin
www.lisakokin.com

Dorothy Simpson Krause
www.dotkrause.com

Hanne Matthiesen
www.hannematthiesen.dk

Bridgette Guerzon Mills
www.guerzonmills.com

Alisa Nordholt-Dean
www.prettylittlependant.blogspot.com

Sam O'Leary
www.conduction.co.nz

Acknowledgments

Thank you, Mati Rose, for being a generous and kind spirit, for being brave enough to say, "Hey! You should do this!" even though we had just met.

Thank you, Mary Ann, for being enthusiastic about this project and guiding me along the way.

Thank you, Andrew, for taking on this project and for being generous with your time, space, and talent!

Thank you, Thao, for being so open and giving, for letting us shoot in your home, and thank you, Sophie, whose creative and curious little spirit was pure sunshine on shooting days and who makes the best imaginary eggs I've ever tasted!

Thank you, Mom, for being my first and best creative role model. Thank you, Dad, for always encouraging me to pursue art in all its forms and for bringing me that first bottle of xylene back from Nevada. Thank you both for always supporting me in all my creative endeavors!

Thank you, Matt, for listening to me wonder out loud how these projects were going to come together, for telling me I could do it, for drawing me lots of little sketches both for this book and just because, and for letting me use your camera!

Thank you, Ava, for letting us shoot in your sun-filled apartment. Your space is the only one that felt like I had hand selected every element; you have great taste!

Thank you, Maria, who sat with me on the sofa, Downton Abbey playing in the background, and read the entire manuscript out loud, going over everything with a fine-tooth comb. You are my voice of reason and a daily inspiration!

Thank you, Ashley, for taking beautiful pictures of your adorable daughter Shirley: you two make me want to make things for little girls all day long.

Thank you, Molly and Maddy (who appear over and over in this book), for being the most beautiful redheads I've ever known and for letting me attempt to capture some of your inner and outer beauty. You are both such amazing women!

Thank you to all the friends who have encouraged me and accompanied me along the way; I am so lucky to have each and every one of you in my life.

Thank you to the artists who contributed to the book: your work inspires me to use image transfers in different ways and reminds me how great beauty can be achieved with these techniques.

About the Author

Courtney Cerruti is a maker extraordinaire. She sees the potential in the discarded, history in the mundane, and art in the everyday. She saves everything, makes anything, and teaches from a place of passion and authenticity. Courtney believes everyone is creative, and she cherishes helping people access that creativity.

Courtney teaches workshops at the San Francisco Center for the Book, various guest locations, and online at Creativebug.com. She is addicted to Instagram (**@ccerruti**), washi tape, and all things old and worn. She lives in the San Francisco Bay Area in a tiny space where she is surrounded by paintings, beautiful objects, and myriad collections.

See more of her work, follow her on Instagram, and get inspired by her pins on Pinterest. Courtney would love to see what readers make using the methods from *Playing with Image Transfers*. Post to instagram and hashtag #playingwithimagetransfers, #pwit, **@ccerruti**.
www.courtneycerruti.com
www.pinterest.com/ccerruti